YES WE DID

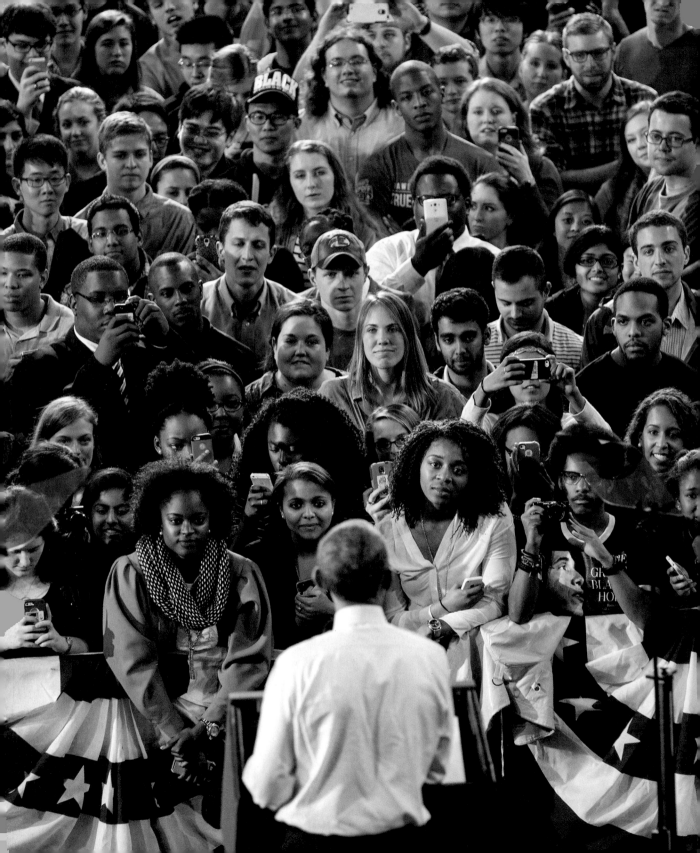

YES

PHOTOS AND BEHIND-THE-SCENES STORIES CELEBRATING OUR
FIRST AFRICAN AMERICAN PRESIDENT

WE

LAWRENCE JACKSON

DID

A TARCHERPERIGEE BOOK

tarcherperigee

An imprint of Penguin Random House LLC
penguinrandomhouse.com

Library of Congress Cataloging-in-Publication Data

Names: Jackson, Lawrence, author.
Title: Yes we did : photos and behind-the-scenes stories celebrating our first african american president / Lawrence Jackson.
Description: New York, New York : TarcherPerigee, an imprint of Penguin Random House LLC, [2019] | Includes bibliographical references and index.
Identifiers: LCCN 2019008976| ISBN 9780525541011 (hardcover : alk. paper) | ISBN 9780525541028 (ebook)
Subjects: LCSH: Obama, Barack—Pictorial works. | Presidents—United States—Pictorial works. | Jackson, Lawrence—Travel. |
Photographers—United States. | United States. President (2009-2017 : Obama)
Classification: LCC E908.3 .J33 2019 | DDC 973.932092—dc23
LC record available at https://lccn.loc.gov/2019008976
p. cm.

Printed in China

10 9 8 7 6 5 4 3 2 1

Book design by Lorie Pagnozzi

For Patrick and Sophia. Thank you for choosing me to be your father. I don't deserve either of you, but I try to live up to the challenge every day. You are kind and good people, which is the most important thing your mother and I could wish upon you.

And to my lovely wife, Alicia. I was right when I gave you the nickname "Trouble" on our first date. But I was also right in calling you for a second date. And a third. And. . . . Thank you for all you've done and continue to do for us and our family.

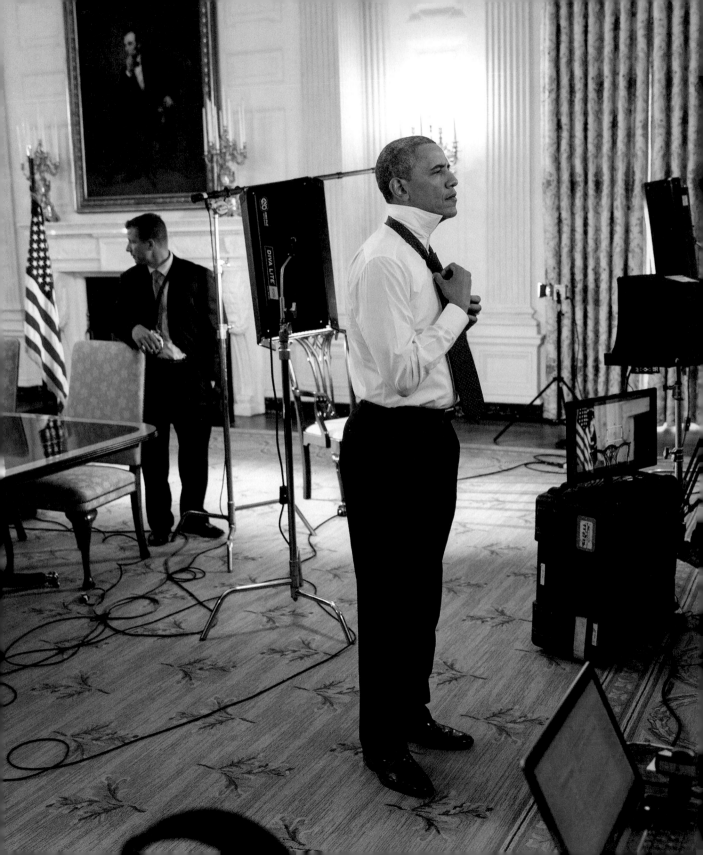

CONTENTS

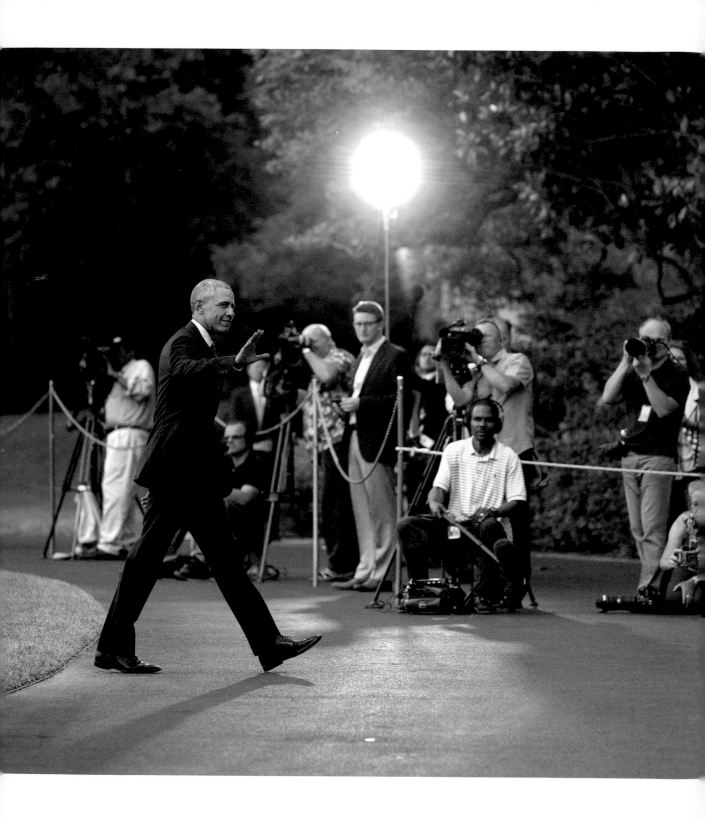

The subject matter is so much more important than the photographer.

—GORDON PARKS

The White House Press covers President Obama upon his arrival on the White House South Lawn following a trip to Orlando, Florida, June 16, 2016.

You're about to sift through some of my favorite memories.

That's one of the odd things about being president: Much of what you do is documented by a swarm of professional photographers and a sea of smartphones. There aren't many private moments. And even most of those have to be recorded for posterity.

That's why we were so grateful to have someone like Lawrence Jackson recording them.

As you're about to see, Lawrence has a talent for capturing the big scene, the iconic images that will help explain our times for future generations. But he also has a unique gift for capturing those quieter moments—the margins of a big event, the pauses in a busy day, some stolen time with Michelle and our girls.

They, in particular, came to adore Lawrence. Michelle and I trusted him to travel the world with her and spend time with our girls as they grew up too fast. And we'll always be grateful to him for preserving some of their youthful joy.

Lawrence brought something else to his work, too. He and I had similar upbringings as black men in America, each of us raised by an extraordinary single mom, both of us knowing what it's like, at times, to feel as if we might not belong. Many of his photos are informed by that sensibility, an added awareness of the meaning that certain moments may hold for those who were so long dispossessed.

I suspect Lawrence pinched himself frequently, feeling fortunate to serve in a time of incredible challenge and change. Some of my favorite photos of his are of other White House staff who surely felt the same—who rarely received credit or fanfare, who never got over the feeling that maybe they weren't supposed to be there either—but all of whom did their jobs with pride and skill and made up a vital part of the White House experience.

I miss them all. Eight years in the White House went by so fast. That's why I'm so grateful that Lawrence was there to capture them. I hope you enjoy his work as much as I do.

—BARACK OBAMA

INTRODUCTION

I n 2008 I was working for the Associated Press as a staff photojournalist covering Capitol Hill, the White House, and D.C.'s major professional sports teams. Working for the AP was a dream job that I truly loved.

On election night 2008 I was assigned to the White House as the world awaited the election results in the presidential race between Senators John McCain and Barack Obama. When the election was called for Senator Obama, I, like much of the country, was overwhelmed with emotion. I raced outside to take pictures in Lafayette Park, where people celebrated with a jubilant and infectious energy I'd never experienced before.

"CAN YOU BELIEVE IT?"

At 1:00 a.m., after filing my pictures, I left the White House and headed to my car. The usually empty streets were still very much alive. As I walked, I noticed another man, another black man, heading in the same direction. We looked at each other with big smiles on our faces. He asked, "Can you believe it?" "I know," I said, with the same sense of elation and awe. That was the moment I knew I wanted to work for the first African American president of the United States.

I applied for the position of chief White House photographer but didn't get it. Later I got an email from Pete Souza, the newly appointed chief White House photographer. He wanted to know if I was still interested in working for this White House. We met for coffee, and he eventually offered me a job as an Official White House photographer.

Going home, the night of Pete's offer, I wasn't sure if I should take it. The government salary would be a significant pay cut, which would mean changes in my family's daily life. My wife looked at me like I was crazy. She said, "I will get a job. But you are *taking* this job and we will make it work." She understood the sacrifices involved and what a remarkable opportunity this job would be—the chance to be part of history. So I called Pete and accepted the offer. I have never once regretted that decision.

FINDING MY LENS

As is the case for most people of color, my journey as an African American has been one of hope, love, setbacks, hard work, trepidation, reflection, luck, and that thing that can't be described. Growing up, I was a shy kid, even more so after my parents divorced and I began to see my father only a handful of times a year, despite the fact that he lived nearby. I was always drawn to photography—in part, I think, because it allowed me to hide behind the camera and still be a witness. When I was fourteen or fifteen, my mom, Arlene Bolden Jackson, bought me a 35mm camera for Christmas—a Pentax K1000, black-and-silver-bodied with a 50mm lens. It was a stretch financially, but she knew how much it meant for me to have it. Suddenly I began to find my "voice" through capturing the world around me.

///////////////////////////////

Looking at the photos I took in the Obama White House, I'm struck now by the intimacy of the images.

I was there to do my job—experiencing epic moments when history unfolded right in front of me, as well as quiet moments of preparation and focus and waiting around for things to happen. It was all hard work. Through it all I felt a greater connection with President Obama that deepened over my eight years at the White House. Like millions of Americans, and certainly African Americans, I felt POTUS44 was truly my president. I was fortunate enough to have a front-row seat to history.

There were many times when I felt he was putting words to the thoughts and emotions bouncing around inside me—things I didn't know how to express. When President Obama talks about his love and respect for his mother, and about not knowing his father, I understand. During his first term in office he gave an amazing speech to the NAACP in New York, which had the crowd on their feet in praise. "There, but for the grace of God, go I," he said in distinguishing himself from so many young black

men who struggle today. For many a black man of a certain age, this message rings all too true. If you don't have a parent, teacher, or mentor looking out for you, or someone capable of giving you a second chance when you make a mistake, then your paths to success start to narrow because any person of color has experienced discrimination— blatant or subtle, purposeful or inadvertent—at some point along the way. It was one of many personal reflections President Obama made in speeches and remarks over those eight years with which I felt a deep sense of connection.

PICTURE YOURSELF HERE. BECAUSE THE FIRST STEP TO ACHIEVING SOMETHING IS NOT JUST TO DREAM IT BUT TO PICTURE IT.

Seeing First Lady Michelle Obama up close for eight years was a similar mix of inspiring and deeply resonant for me personally. After all she had accomplished in her life and career before coming to the White House, she dedicates herself to helping others achieve their best too. Something she always said to schoolkids who visited struck a particular chord in me: *This house belongs to all of us. But this isn't just a onetime visit. Picture yourself here.* Because the first step to achieving something is not just to dream it but to picture it.

Just as President Obama and First Lady Michelle brought their personal journey with them to the White House every day for eight years, I carried my journey as a black photographer with me to my role as an Official White House photographer, bearing witness to his presidency. The experience was a powerful one, which I've tried to document in the photos I took there over eight history-making years.

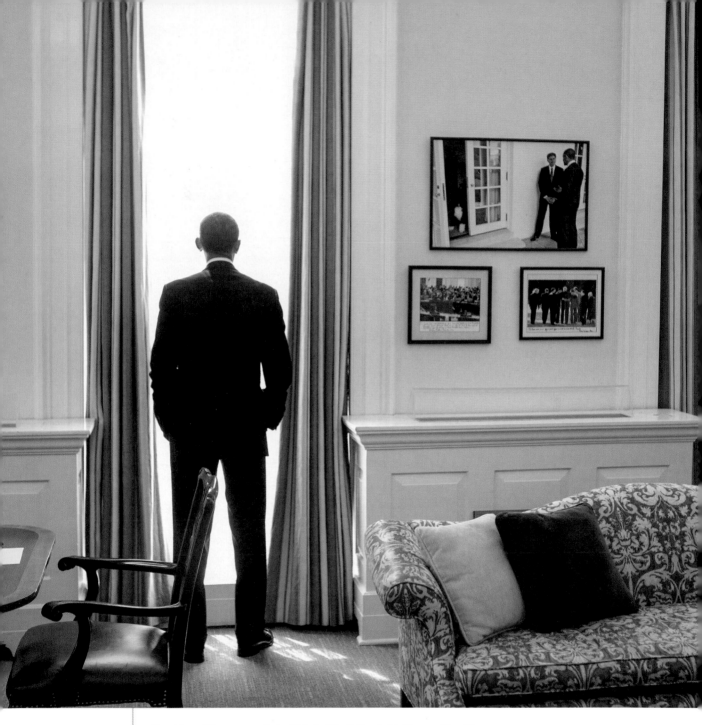

President Obama stands in Chief of Staff Denis McDonough's office between takes of taping for White House social media, June 4, 2012.

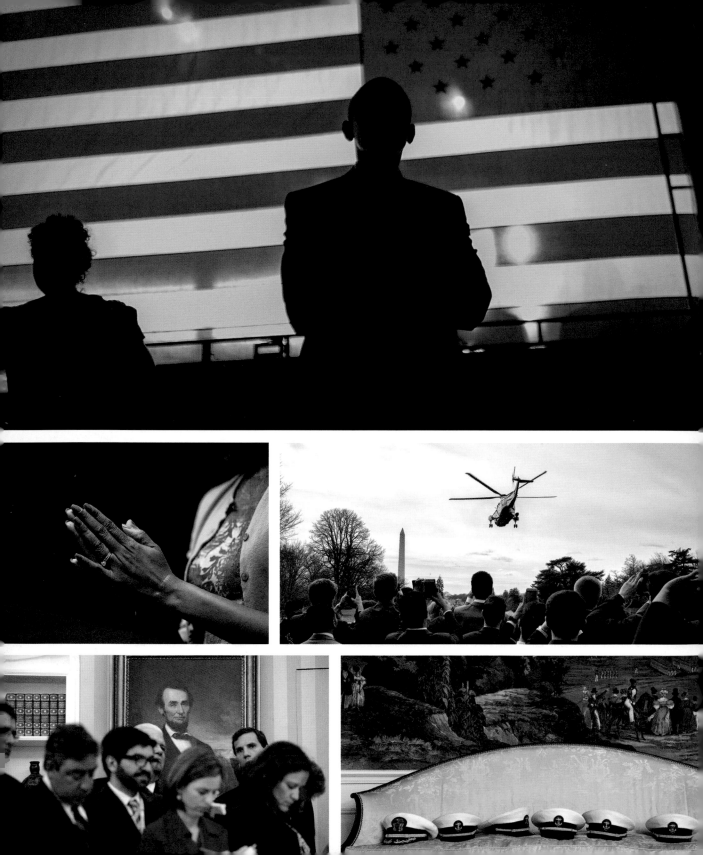

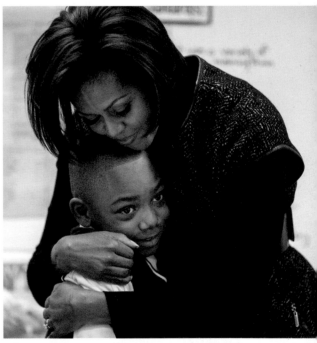

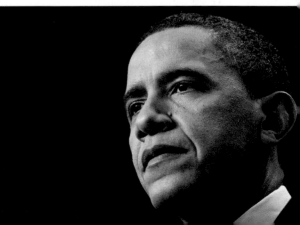

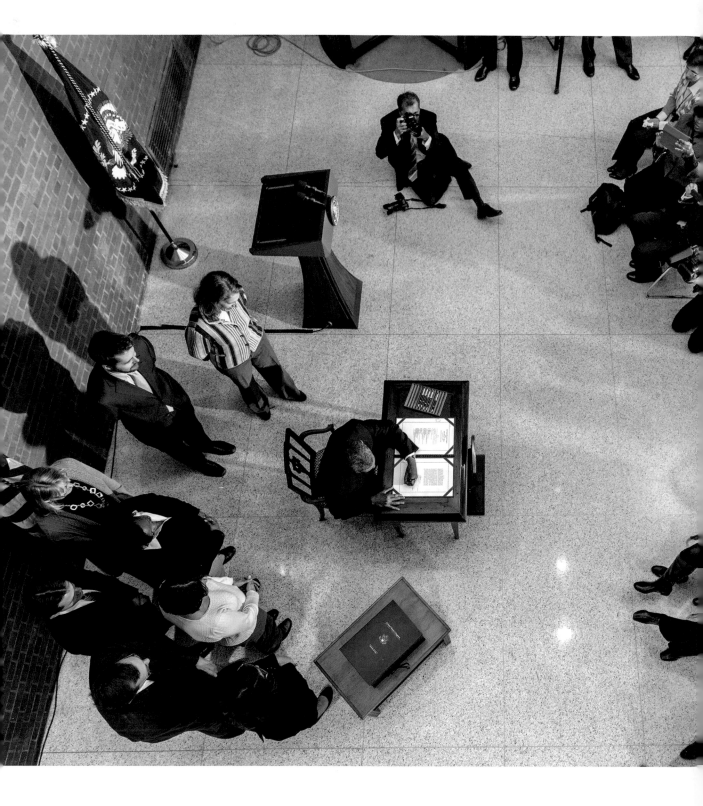

MAKING HISTORY

There is never a guidebook for those who come first. The first person to fly solo around the world, the first African American Supreme Court Justice, or the first woman to run the Boston Marathon. The stakes couldn't be higher for these pioneers of history—nor could the cost of failure.

I was crawling on my hands and knees trying to find a good position while staying as quiet as possible as President Obama gave a TV interview with ABC News in the Map Room of the White House. It was the very first of what would be many interviews in which I would document him during the next eight years. I'd been on the job, at most, two weeks and was still getting the lay of the land and a feel for the rhythm of our forty-fourth president. Yes, of course I was nervous—

President Obama signs into law an omnibus spending bill in the New Executive Office Building, January 17, 2014.

would my camera shutter or my very presence bother him? It turns out he is one of the more focused people I've ever covered, and these things didn't distract him at all.

As much as I wanted to take compelling pictures of this interview, I wanted *him* to succeed even more, because so much was riding on his shoulders. As the first African American president, he had no room for error. If he said or did something wrong or appeared unprepared, it would vindicate his detractors. But it never happened. In the years of covering him in interviews, his pauses were always in search of the right words and tone, reflective of the moment. I watched him, and I learned from him. I absorbed his calm demeanor and projected it when doing my job as an official White House photographer.

EVERY DAY THEY WERE MAKING HISTORY, AND HISTORY WAS MAKING THEM.

You can learn a lot by watching and listening. My tenth-grade math teacher used to tell us, "Nobody knows how stupid you are until you open your mouth." As harsh as the statement was, she was right. When you're talking, you aren't listening, learning. So I watched them, President Obama and First Lady Michelle, learn on the job. I watched them exercise the power of influence with dignity and respect. I watched them lead by example. I watched them steal naps on the plane between cities or backstage before events because they had been going all day and had more events ahead that evening. I watched them practice their remarks and discuss the impact of a policy change during staff meetings. I watched them truly engage with people, with empathy and an unshakeable calmness and focus—because to lead effectively you have to be a good listener.

Every day they were making history, and history was making them.

For me, taking pictures was the easy part. Knowing *when* to take pictures was the learning curve.

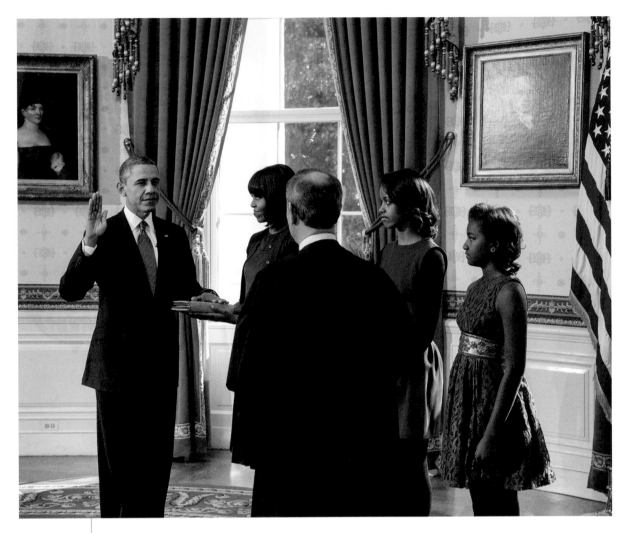

Supreme Court Chief Justice John G. Roberts Jr. administers the oath of office to President Barack Obama during the official swearing-in ceremony in the Blue Room of the White House on Inauguration Day, January 20, 2013. First Lady Michelle Obama holds the Robinson family Bible. Daughters Sasha and Malia stand with their parents.

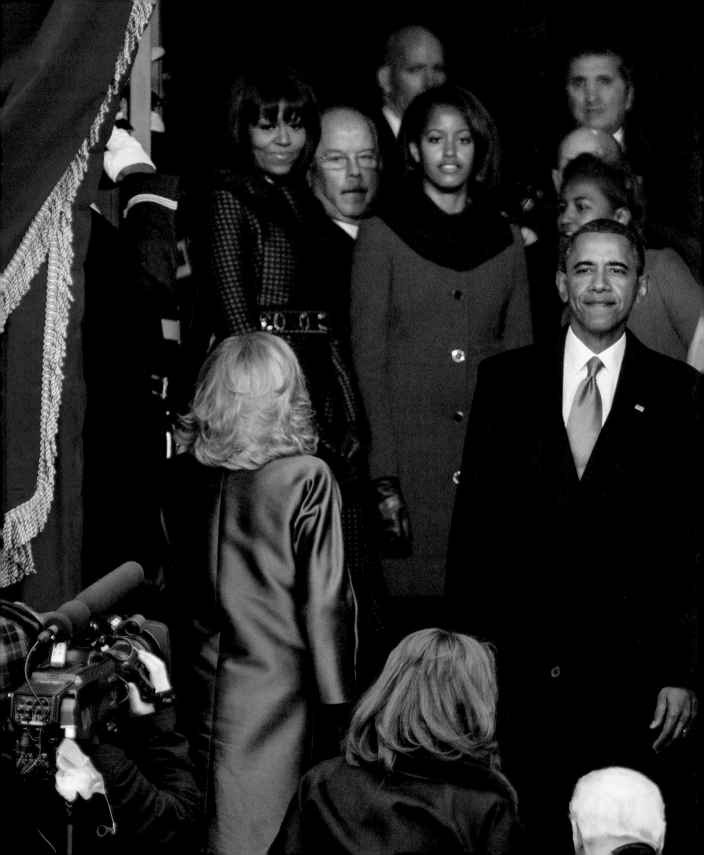

President Obama stops to look back at the crowd on the National Mall before leaving the platform following his second inaugural swearing-in ceremony at the U.S. Capitol in Washington, D.C., January 21, 2013. Standing behind the President are First Lady Michelle Obama, daughters Malia and Sasha, and Marian Robinson.

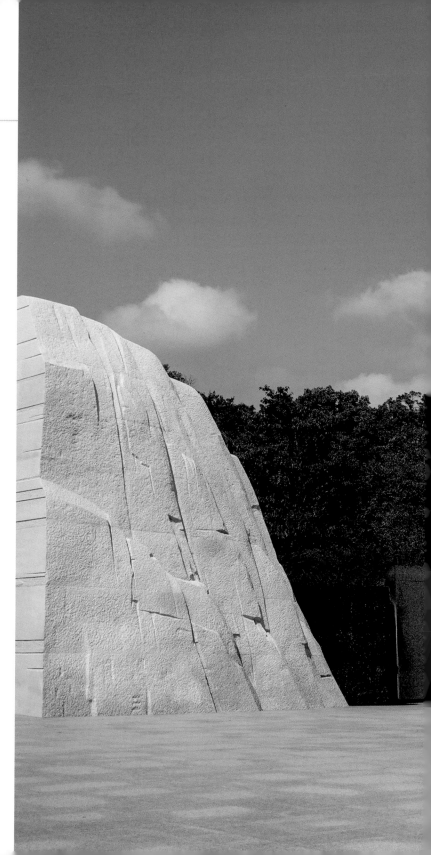

President Obama and Prime Minister Narendra Modi of India visit the Martin Luther King, Jr. Memorial on the National Mall in Washington, D.C., September 30, 2014.

FOLLOWING PAGE:
President Obama, First Lady Michelle Obama, and daughters Sasha and Malia along with Representative John Lewis, D-Ga., walk with guests and the original Freedom Walkers across the Edmund Pettus Bridge to commemorate the fiftieth anniversary of the Selma-to-Montgomery civil rights marches, in Selma, Alabama, March 7, 2015.

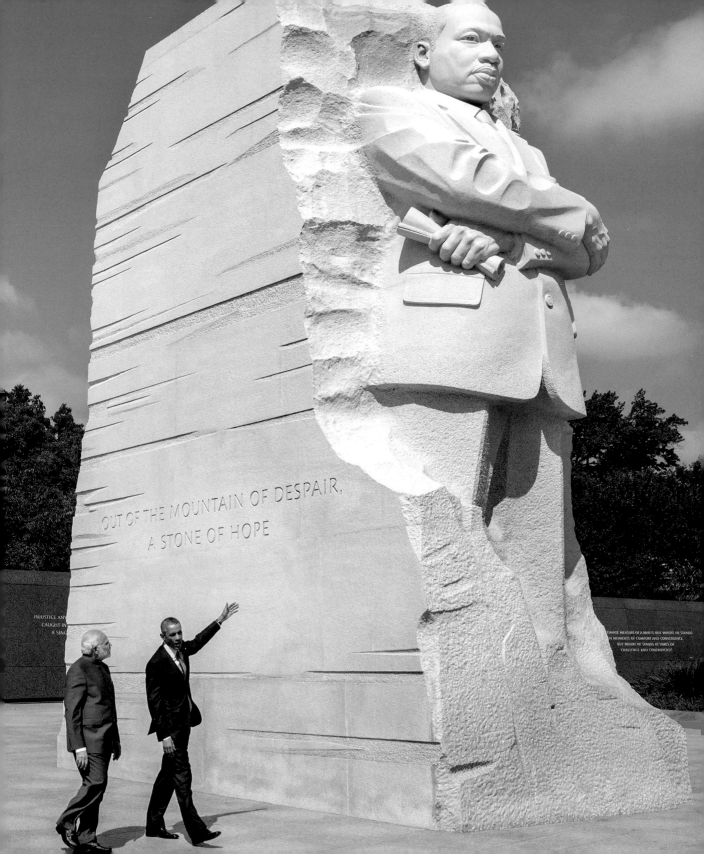

OUT OF THE MOUNTAIN OF DESPAIR,
A STONE OF HOPE

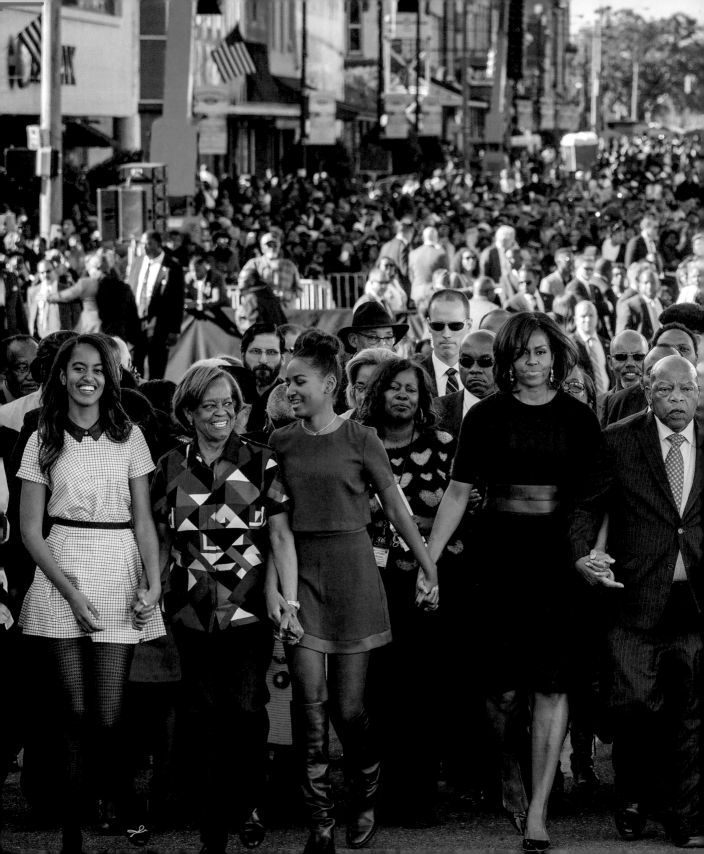

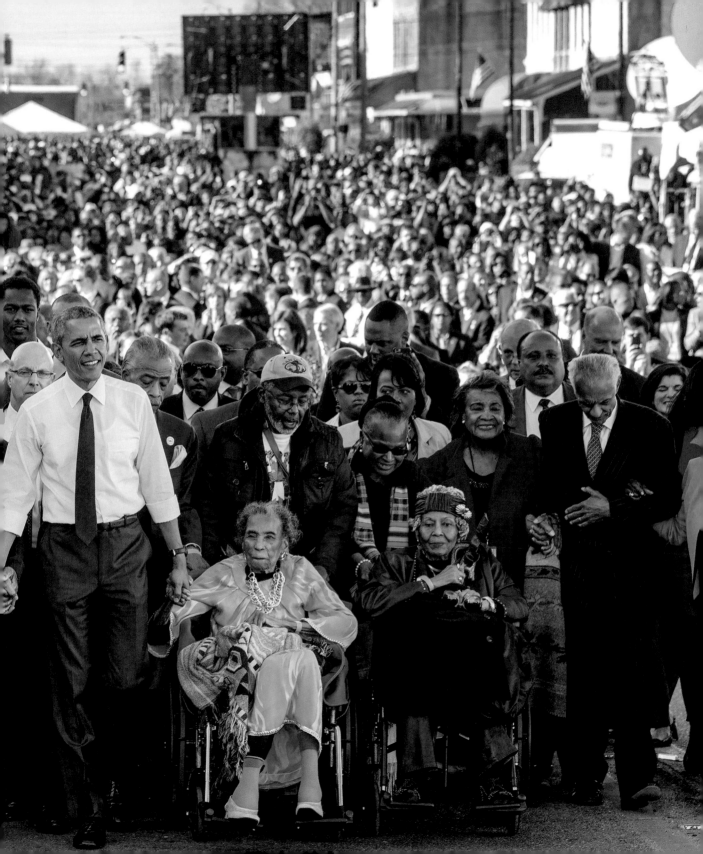

BENDING TOWARD JUSTICE

The speech to commemorate the fiftieth anniversary of the Selma-to-Montgomery civil rights marches was, in my opinion, one of President Obama's best. It was an honest look at our past, present, and possible future as a country. Usually when I'm taking pictures during an event, I'm only getting parts of the speech because it's hard to truly listen and take pictures at the same time. But this speech, on this occasion, being given by the first African American president, had me listening more than I was taking pictures.

IT'S THE IDEA HELD BY GENERATIONS OF CITIZENS WHO BELIEVED THAT AMERICA IS A CONSTANT WORK IN PROGRESS; WHO BELIEVED THAT LOVING THIS COUNTRY REQUIRES MORE THAN SINGING ITS PRAISES OR AVOIDING UNCOMFORTABLE TRUTHS. IT REQUIRES THE OCCASIONAL DISRUPTION, THE WILLINGNESS TO SPEAK OUT FOR WHAT IS RIGHT, TO SHAKE UP THE STATUS QUO.

The lessons of race relations, immigration, discrimination, and civil disobedience are real to so many Americans. The keys to change, or the progress of moving forward, are in speeches and peaceful acts of protest like this march was so many years ago. And as in so many other speeches of importance, President Obama found the words and sentiments I felt rolling around in my head and heart but didn't know how to express. The pictures captured this day—from POTUS and FLOTUS quietly holding hands onstage to the passion with which he delivered his remarks to the crossing of the bridge and the singing of songs like "Keep Your Eyes on the Prize"—were as honest and sincere as could be expected with such a choreographed event that was seen around the world.

It was one of many special moments over eight historic years, during which I remembered to keep taking pictures—most of the time. ■

Fifty years ago today, we set out to march from Selma to Montgomery to dramatize to the nation that people of color were denied the right to vote. Some people love the world, but they don't love people. You have to respect the dignity and worth of every human being. Love everybody. When people tell me nothing has changed, I say come walk in my shoes and I will show you change.

—REPRESENTATIVE JOHN LEWIS, D-GA.

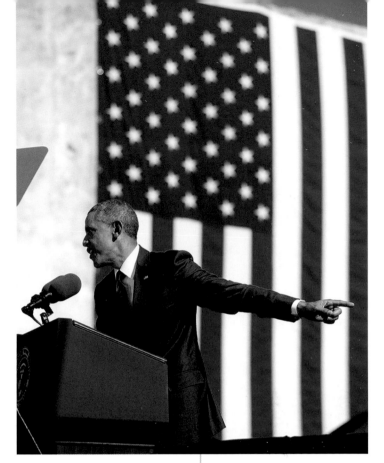

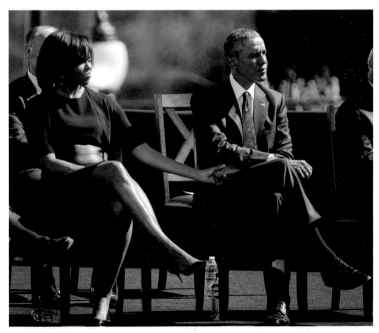

President Obama delivers remarks during an event to commemorate the fiftieth anniversary of the Selma-to-Montgomery civil rights marches, at the Edmund Pettus Bridge in Selma, Alabama, March 7, 2015.

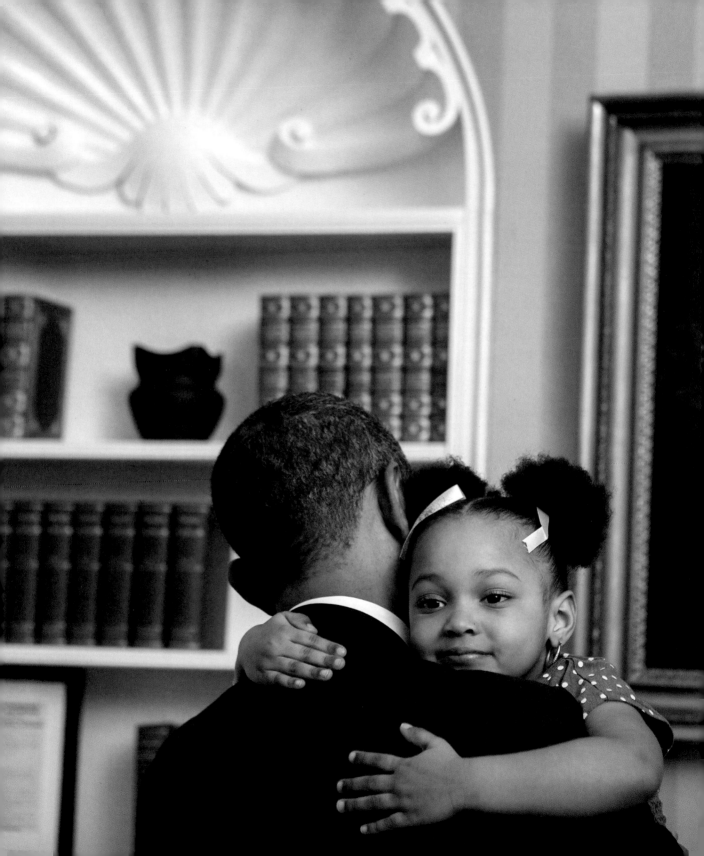

“I have darkened the oak-paneled door of many a United States senator over the years, and I've gotten pretty familiar with the kinds of pictures you see on the walls in their offices: senator shaking the hand of president or general; senator smiling with sports team from home state; senator holding up very large fish senator has caught. Standard fare.

So imagine my surprise when I stepped into the office of Senator Pat Leahy recently and saw this picture in a frame. It stopped me in my tracks. First of all, there's not a single senator in it. But the main reason I took such a good long look (and asked Lawrence Jackson for a copy, so I can keep on looking) is because it captures a moment so magical and improbable that it cannot be reduced to a caption (or an essay).

All I can tell you is what it stirs in me right now.

I look at this beautiful child and I think: What would we want her to understand about power? What do we want her to know about how power is exercised and on whose behalf, about

President Obama hugs Arianna Holmes, three, before taking a departure photo with members of her family, who were departing White House staffers, in the Oval Office, February 1, 2012.

FOLLOWING PAGE: President Obama walks First Lady Michelle Obama to her plane after they delivered remarks to the troops at the 3rd Infantry Division headquarters in Fort Stewart, Georgia, April 27, 2012.

who we hope her to be when she herself (we hope, we insist) holds power in the arena of her choosing?

The photo is taken at the center of power. But what this picture says to me about power has nothing to do with its usual instruments: economic, military, cultural might. What this photograph shows—and what President Obama showed us during his years in office—is just how much power there is in restraint, in goodness, in grace, in love.

Maybe we understand this more in its absence. Because there's another model of leadership that is finding its way to center stage on both sides of the Atlantic, one that's grabbed the megaphone and is shouting that goodness and grace are signs of weakness, not strength. We are seeing a power that defines itself by demonizing "the other." I'm Irish, and we have been "the other." It's a dark force. It drives people apart, pushing against human nature. Desmond Tutu, the Arch, a hero of President Obama's, talks about the concept of "Ubuntu": I am, because we are.

I think Abraham Lincoln would have been a fan of that too. Here he is, inadvertently photobombing this intimate hug . . . a man holding a child who is not just being held but who is holding him back. Look at her arms, her hands. Lincoln is no bystander in this shot, though. He, as I understand him, saw the exercise of power in much the same way as Obama. "Nearly all men can stand adversity," noted Lincoln, "but if you want to test a man's character, give him power." In times of division he called on the "better angels of our nature." In this as well as other ways President Lincoln makes President Obama possible (as Obama himself has made clear).

Looking again at this little girl: What does Barack Obama make possible? For that matter, what does Michelle Obama make possible? The photo poses this question. And just maybe an answer.

—BONO
December 2018

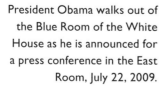

President Obama walks out of
the Blue Room of the White
House as he is announced for
a press conference in the East
Room, July 22, 2009.

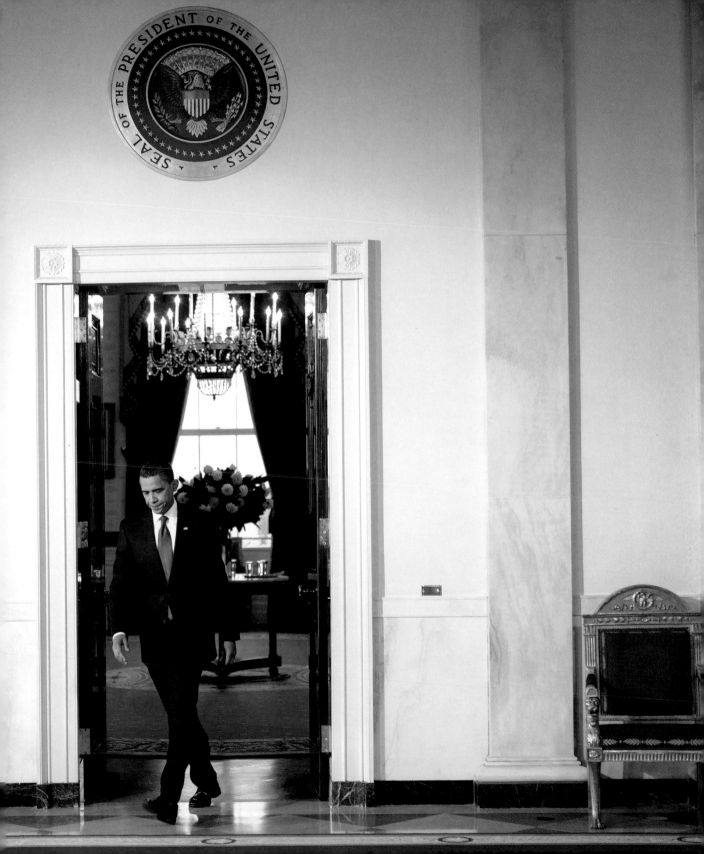

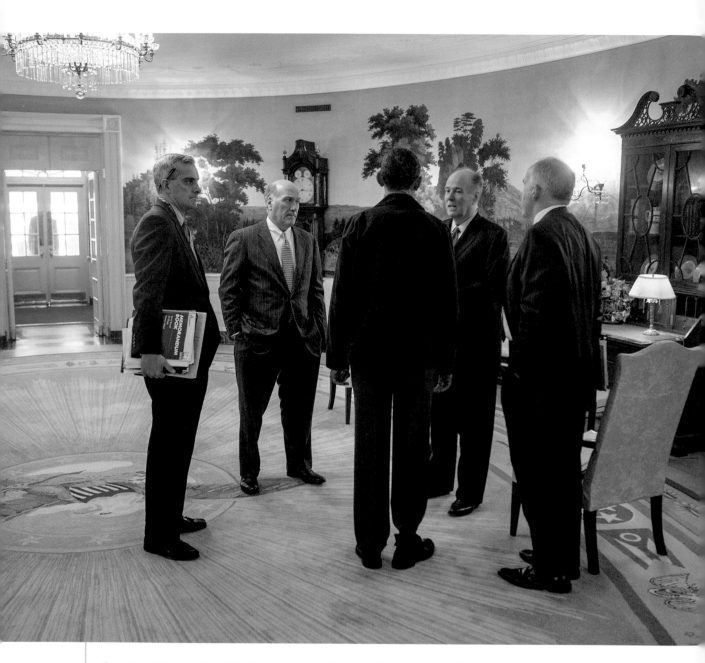

President Obama talks with, from right: John Brennan, Assistant to the President for Homeland Security and Counterterrorism; National Security Advisor Tom Donilon; Chief of Staff Bill Daley; and Deputy National Security Advisor Denis McDonough in the Diplomatic Room of the White House prior to departure en route to Tuscaloosa, Alabama, April 29, 2011.

GIVING THE ORDER

It was a beautiful spring morning on the South Lawn of the White House as Marine One sat waiting for President Obama and the First Family to depart for Cape Canaveral for one of the final launches of NASA's Space Shuttle. My job that day was to document their departure. As I waited in the Diplomatic Room of the White House, I noticed a gathering of National Security Council staff and senior advisors—Denis McDonough, John Brennan, Tom Donilon, and Chief of Staff Bill Daley. They seemed anxious before his arrival, which in turn made me anxious.

KNOWING WHEN AND WHERE TO GIVE THE PRINCIPAL SPACE IS A DELICATE DANCE.

As the President strode into the Diplomatic Room, I had a decision to make: Do I get in there and take pictures, or do I give them space as they brief the President on whatever it was they had to tell him? Knowing when and where to give the principal space is a delicate dance. But I decided to take pictures because that's my job. I knelt down, composing my shot with the President's back to me as the senior advisors listened closely to his every word. I got off two frames before John Brennan noticed I was taking pictures and began to frantically wave me off, as if to say, "Get out of the room." I quickly left, feeling silly but not really thinking much of it. It wasn't until later that we all found out this brief meeting was the President giving the go-ahead for the Osama bin Laden raid in Abbottabad, Pakistan, by SEAL Team Six. This picture was released and used by news outlets to show a timeline of what President Obama's schedule was like the weekend of the raid. ■

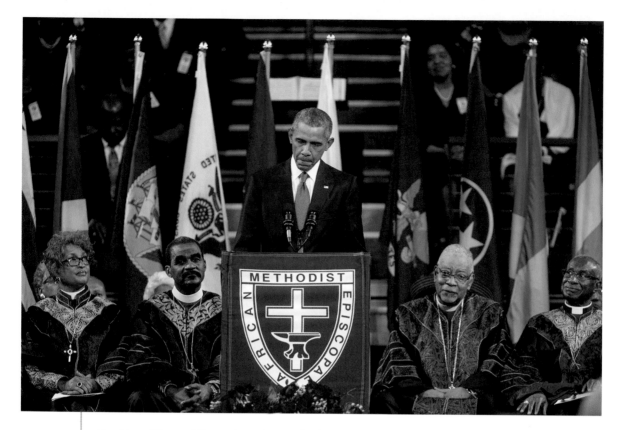

President Obama delivers the eulogy at the funeral of Reverend
Clementa Pinckney at the College of Charleston in Charleston, South
Carolina, June 26, 2015. Reverend Pinckney, who was also a South
Carolina State Senator, was one of nine African Americans murdered
at Mother Emanuel A.M.E. Church on June 17, 2015.

President Obama walks back
to the Oval Office after bidding
farewell to Pope Francis on the
South Lawn of the White House,
September 23, 2015.

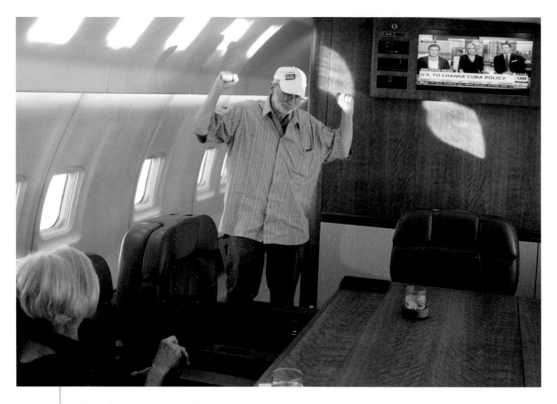

Alan Gross pumps his fists in the air after the pilot announces they are leaving Cuban air space while onboard a government plane headed back to the United States with his wife, Judy Gross, December 17, 2014.

HISTORY IN THE MAKING

On December 16, 2014, as I was having dinner with my family, I got an email from my boss, asking me to call him. I can count on one hand the number of times Pete asked me to call him, so I knew something was up. He said there was a flight I needed to catch in the morning and I would get the details when I got to Joint Base Andrews. I couldn't tell anyone about the trip. Not even my wife, who clearly knew something was up when I returned to the table.

When I arrived at Joint Base Andrews, I was joined by Senators Jeff Flake and Pat-

rick Leahy and Representative Chris Van Hollen, along with some White House staff, a flight crew, and the wife and the lawyer for Alan Gross, an American contractor who had been a prisoner in Cuba for five years. Their mission was to take part in a three-way prisoner exchange and restart U.S.–Cuban relations.

According to the time stamp on my images, we were on the ground in Cuba for just thirty-eight minutes, but it felt like a lifetime. We walked along an old airstrip with stucco-sided buildings dating back fifty years, to a building where Mr. Gross was waiting with Cuban officials. He greeted his wife with a long embrace and kiss. While the paperwork was being signed, I don't think Mr. Gross ever sat down. He was ready to go.

The mood became a bit tense when we were held up for just a few minutes as the other prisoners in the exchange took a little longer than anticipated. But soon we were on the plane and taking off back to the States. As we flew back to Joint Base Andrews, the news was breaking on the cable outlets. "U.S.–Cuba Relations Reset."

Mr. Gross pumped his hands in the air when the pilot announced we had just left Cuban air space. While chowing down on a corned beef on rye sandwich with seltzer water (his requested meal), a military flight attendant came to tell Mr. Gross that President Obama was calling to speak with him. I could hear only half of the conversation, but Mr. Gross, with the phone pressed hard against his ear, thanked the President and told him he was happy to be headed home.

There are few moments in life when you get to witness history in the making. To be a witness and photographer to the start of the "Cuban Thaw"—and to subsequently go back to Cuba with Dr. Jill Biden a year and a half later on a cultural exchange—was a top-five highlight of my time at the White House. ▪

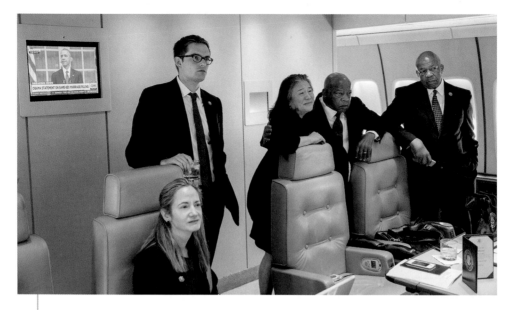

Members of Congress and White House staff watch from Air Force One at Joint Base Andrews as President Obama delivers a statement regarding the Supreme Court ruling on same-sex marriage from the Rose Garden of the White House, June 26, 2015. Left to right. Avril Haines, Bobby Schmuck, Tina Tchen, Representatives John Lewis, D-Ga., and Elijah Cummings, D-Md.

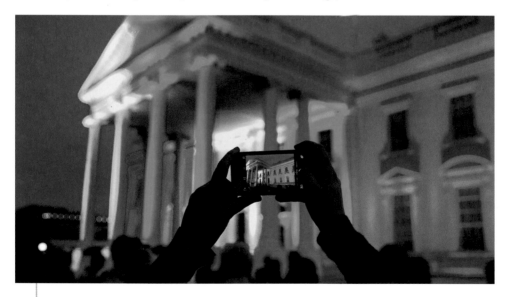

White House staff members and friends gather outside the White House as it is lit up in the rainbow colors representing the LGBTQ community celebrating the Supreme Court decision on same-sex marriage, June 26, 2015.

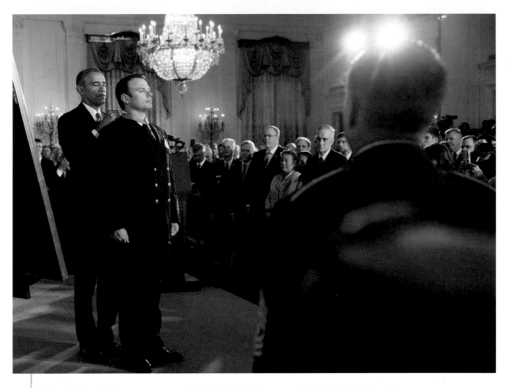

President Obama presents the Medal of Honor to Senior Chief Special Warfare Operator Edward Byers, U.S. Navy SEAL, in the East Room of the White House, February 29, 2016. The Medal honored Byers's courageous actions while serving as part of a team that rescued an American civilian being held hostage in Afghanistan on December 8–9, 2012.

President Obama awarded the Medal of Honor to forty-seven military service members going as far back as the U.S. Civil War to the war in Afghanistan. He has given more Medal of Honor Awards than Presidents George W. Bush, Bill Clinton, and George Bush combined.

Admiral Mike Mullen (ret.), former Joint Chiefs of Staff under President George W. Bush and President Obama, recalls both men "presiding over the solemnity, the celebration, and the dignity of these special and unique American events. Each has done so with a compassion, a profound respect, and humility, while demonstrating a clear understanding of the importance of each person touched, as it touches them in their deep reflection on the most significant and difficult responsibility of every Commander-in-Chief."

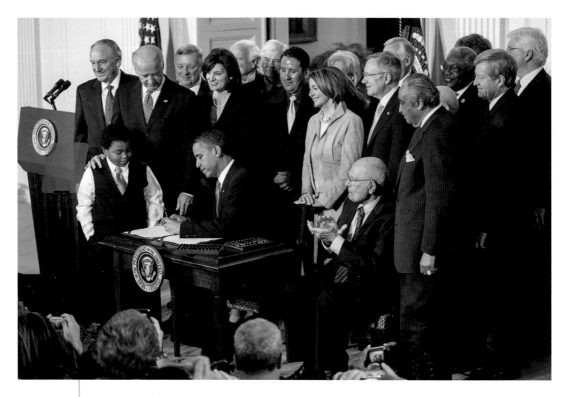

President Obama signs into law the Affordable Care Act in the
East Room of the White House, March 23, 2010.

WHAT IS NECESSARY. WHAT IS RIGHT.

In my eight years, at that point, of covering White House East Room events—both as
an Associated Press and White House photographer—I had never seen it as packed as it
was on March 23, 2010. That was the day President Obama signed into law the Afford-
able Care Act. It was his first major legislative achievement—one that other presidents
had tried, but failed, to get done. The emotion and energy were palpable after the hard-
fought battle on both sides.

During his remarks before signing the bill, the President talked about the challenges
of getting it through both chambers of Congress. But he ended his remarks by saying,
"We are a nation that faces its challenges and accepts its responsibilities. We are a na-
tion that does what is hard. What is necessary. What is right. Here, in this country, we

shape our own destiny. That is what we do. That is who we are. That is what makes us the United States of America."

My camera position in the room was fixed because the space was so tight that no one could move around. But I noticed then Representative Patrick Kennedy, D-RI., holding a copy of the bill's commemorative preamble. It had a personal note from Edward M. Kennedy Jr., son of the late Senator Ted Kennedy of Massachusetts. It read, "Tuesday March 23, 2010. The day, Mr. President when you completed what my Dad once called 'the great unfinished business of our country.'" ■

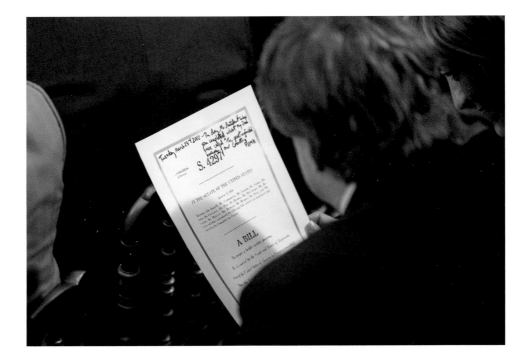

President Obama composes and sends his first tweet as President of the United States from the Oval Office, May 18, 2015.

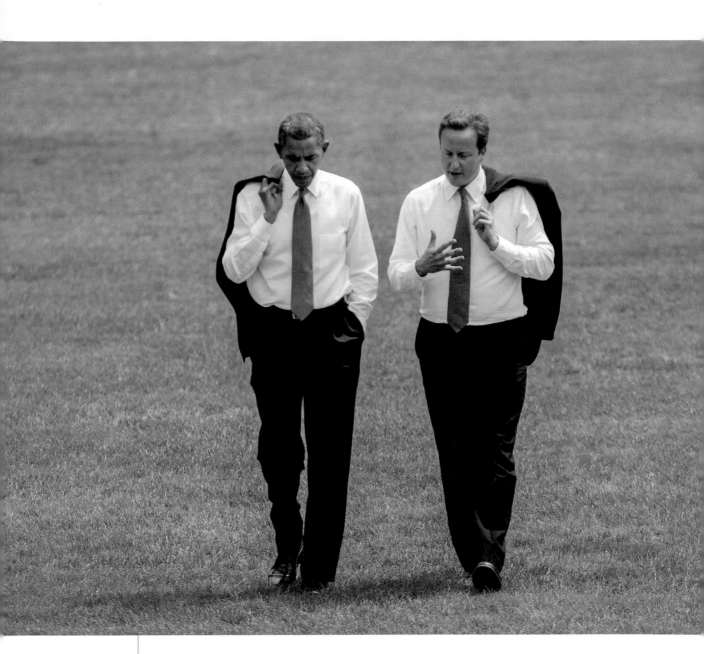

President Obama walks on the South Lawn of the White House with Prime Minister David Cameron of the United Kingdom, July 20, 2010.

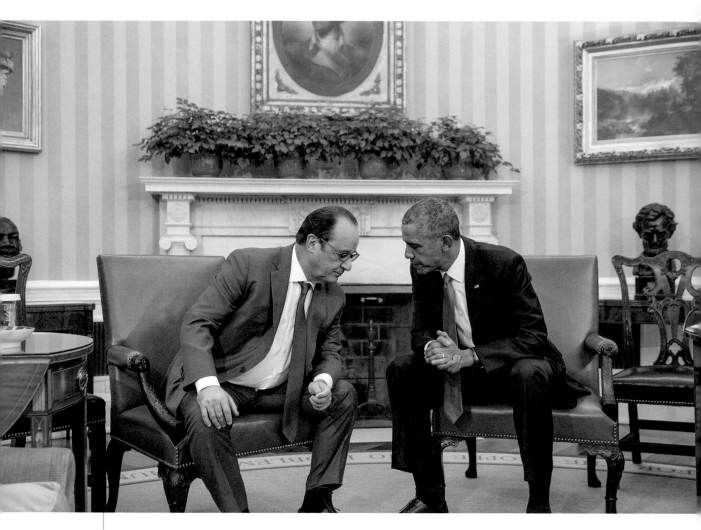

President Obama with President François Hollande of France in the Oval Office during a pool spray with the press, November 24, 2015.

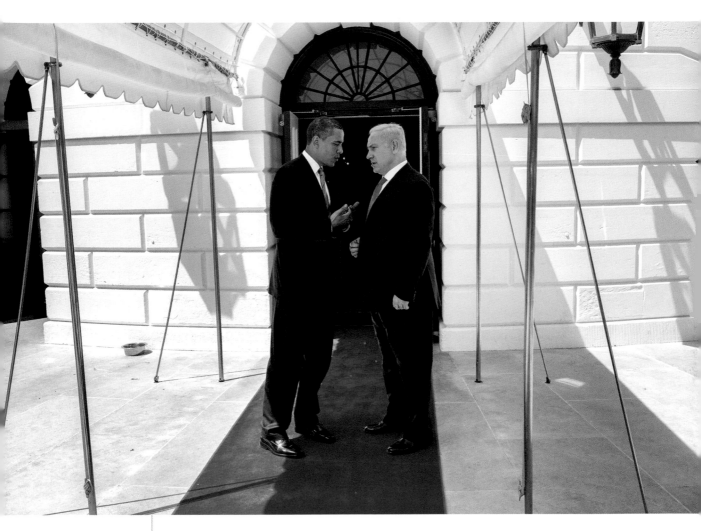

President Obama and Prime Minister Benjamin Netanyahu of Israel talk just outside the Diplomatic Room on the South Portico of the White House, May 18, 2009. This picture was taken after their first face-to-face meeting since both had taken office. I wasn't close enough to hear what they were saying, but the body language of the two men seemed forthright and eager. Listening. Talking. Each trying to get their point across to the other. The Middle East peace plan was very high on President Obama's agenda throughout his presidency, and I remember feeling hopeful that it could be resolved under his administration.

FOLLOWING PAGE: President Obama walks through the Rose Garden of the White House to sign the H.R.2 Medicare Access and CHIP Reauthorization Act of 2015, April 16, 2015.

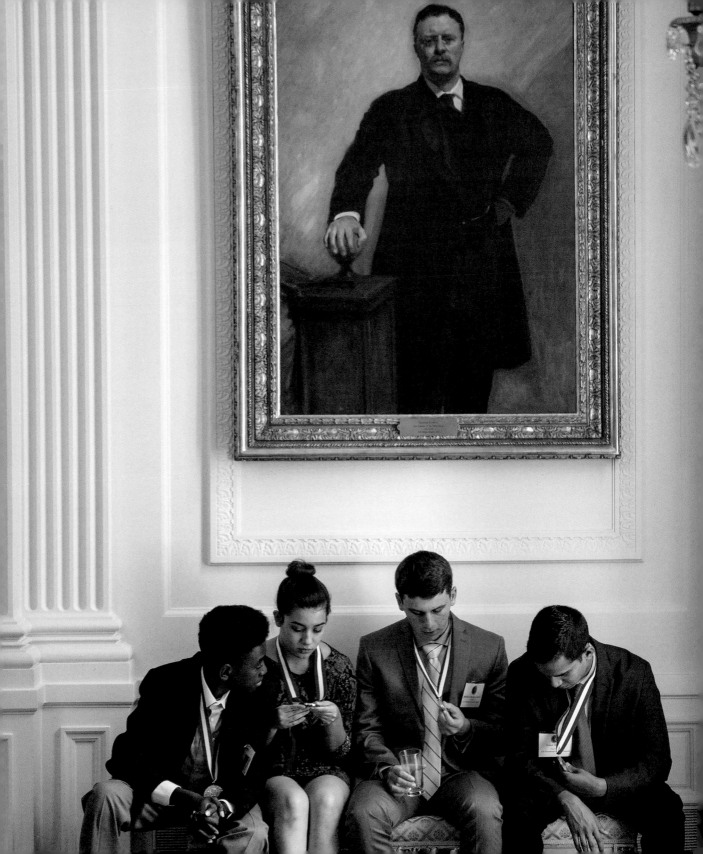

THE PEOPLE'S HOUSE

I n the People's House, also known as the White House, there were times I would be by myself, setting up a light in the Oval Office, or in the Blue Room, or in the Diplomatic Room, and my imagination would take me back in time, to the historic moments that had come before in those spaces. The White House is a living, breathing museum. While standing in the Oval Office I pictured President Kennedy meeting with Reverend Martin Luther King, Jr. in August 1963, before the March on Washington. In this same room President Johnson debated the merits of the Civil Rights Act and used the power of his Oval Office to get it passed.

Recipients of the U.S. Presidential Scholars award check out their medals. The event was hosted by First Lady Michelle Obama in the East Room of the White House, June 23, 2014. The program honors 141 of our nation's most distinguished graduating high school seniors and was expanded in 1979 to recognize students who demonstrate exceptional talent in the visual, creative, and performing arts.

It got to me when I looked at photos from previous administrations and I saw the very same objects that are still there today. Presidents Kennedy, Carter, Reagan, Clinton, and Bush 43 all used the Resolute Desk before Obama. There's a picture of Presidents Eisenhower and Kennedy on the North Portico steps of the White House—steps I walked by almost every day when I worked there. The South Lawn is the same space in which former President Nixon gave his final salute before boarding and departing on Marine One.

President Obama would often say, "We are just renters," when referring to living in the White House. But he and First Lady Michelle truly opened the doors of the People's House to more visitors than any other previous administration. The number of visitors, from the annual White House Easter Egg Roll to the general tours of the White House, were at record levels during those eight years. They may have been renters, but they definitely threw a lot of parties.

During the celebration of Black History Month 2016, the last such celebration during the Obama administration, I got a chance to take pictures of President Obama and First Lady Michelle as they greeted Virginia McLaurin, a then 106-year-old African American woman who lived in the District. I watched as they were delighted by her energy and smile and welcomed her to the White House. Mrs. McLaurin's grin and excitement over meeting the first African American POTUS and First Lady was infectious. I couldn't help but think of all that Mrs. McLaurin had seen and experienced over the many decades, including discrimination and segregation. She said in a subsequent interview, "I never thought I'd see the day when a black man would be President of the United States," and there she was dancing and holding both of their hands.

The People's House was truly open to all. Beyond world leaders and other special guests, the Obama White House hosted young and old, from every background, identity, and country around the world. Through the arts (dance, music, and acting), STEM (science, technology, engineering, and math), the White House Kitchen Garden, Wounded Warrior visits, and more, President Obama and First Lady Michelle invited, celebrated, and inspired people of all ages.

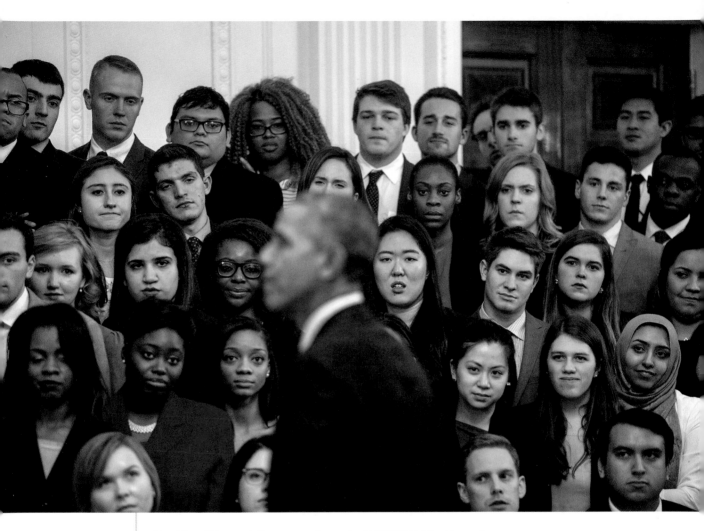

President Obama delivers remarks to the Fall 2015 White House interns before joining them for a group photo in the East Room of the White House, December 3, 2015.

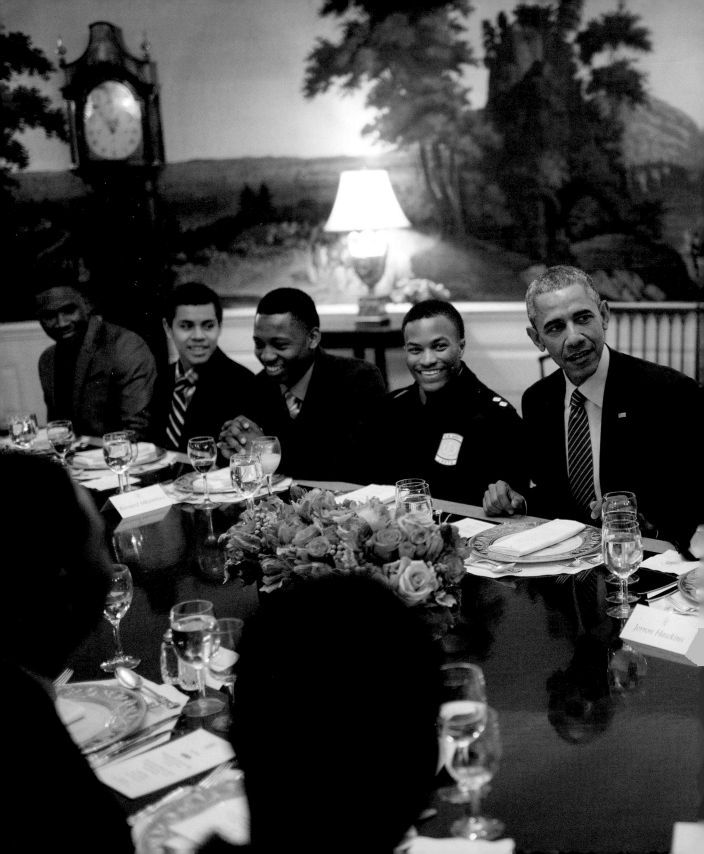

President Obama meets with My Brother's Keeper mentees during lunch in the Diplomatic Room of the White House, February 27, 2015. The MBK initiative was launched by the President in 2014 to address persistent opportunity gaps facing boys and young men of color and to ensure all youth can reach their full potential.

Before our official White House performance, we were offered an opportunity to meet the President and First Lady, if we could gather the children quickly, keep them quiet while waiting, and be prepared to offer a thirty-second song selection.

Waiting for them to arrive, I could not help but think of all the rehearsals, preparation, and fund-raising that led us to this performance trip—and this very moment. I glanced over the children as any proud teacher would. I suddenly realized there were students in that room who represented almost every housing project in our city—the Brewsters, the Martin Luther King Homes, Brightmoor Community, and even Mack and Bewick . . . and they were here, beautifully poised and eagerly anticipating a historic moment.

As the President and First Lady individually greeted each of my twenty-five students, the First Lady with a kiss and hug for each child and the President with a firm handshake and hello, I noticed that one of my students was overcome with emotion. As London's eyes welled up with tears, the First Lady caressed her face, smiled, and told her, "And I am happy to see you too!"

As the kids sang—"What Christmas Means to Me" by Stevie Wonder, chosen because he's a favorite artist of the President—I glanced over at Eric as he serenaded our First Lady while her husband looked on, grinning, toe-tapping, and even clapping along. At one point, the President joked, "Don't call my wife 'baby,'" in response to the lyrics. We were all giddy, wide-eyed, and full of pride.

Soon we were escorted to the main reception space to perform for the full audience. As I directed the kids on the first song, I heard whispers from onlookers behind me: "Oh, they're good . . . They are so darling . . . The President should see this!"

—ANGELA KEE, Choir Director at
Detroit Academy of Arts and Sciences

President Obama jokes with the Detroit Academy of Arts and Sciences Show Choir in the Diplomatic Room of the White House, prior to their holiday concert, December 4, 2015.

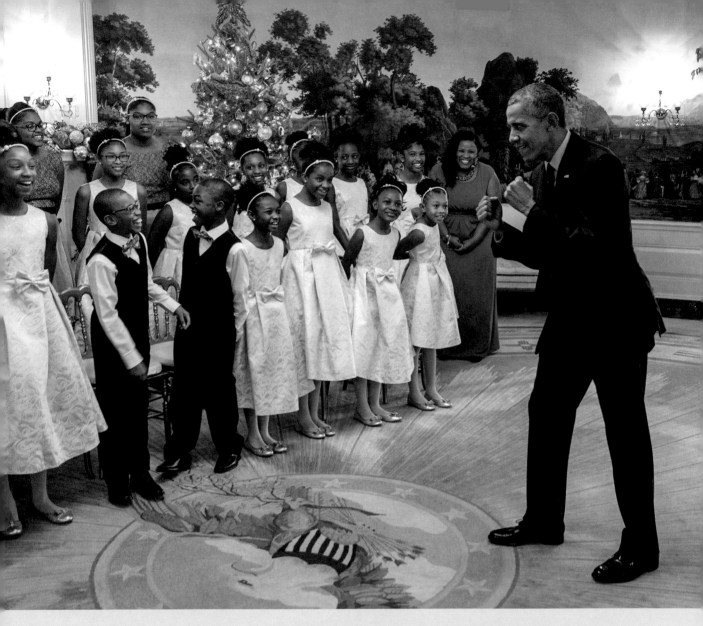

I was scared and excited at the same time, because I was afraid that I was going to mess up on the lyrics. But I did just fine. I was so honored to meet and perform for the President and First Lady. This had always been my dream. And ever since that day, I now have the confidence to sing by myself in front of everyone. This moment was the best event of my life. Thank you, Barack Obama, for letting me show my talent to you.

—ERIC BROWN, now fourteen,
student at Detroit Academy of Arts and Sciences

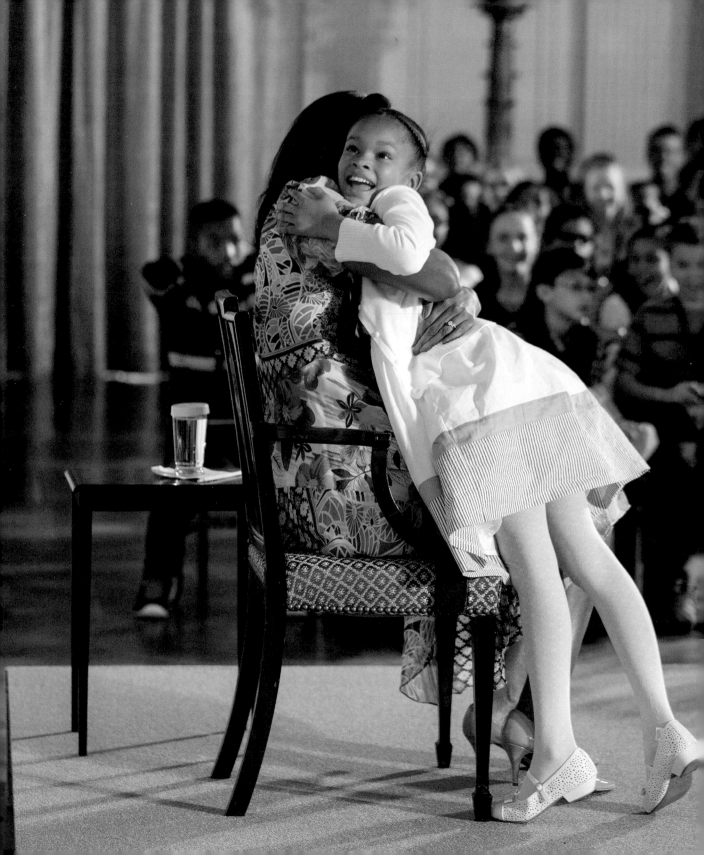

The First Lady delivers remarks and takes questions during the annual Take Our Daughters and Sons to Work Day event in the East Room of the White House, April 22, 2015. She hugs a young girl in the audience who said First Lady Michelle was beautiful.

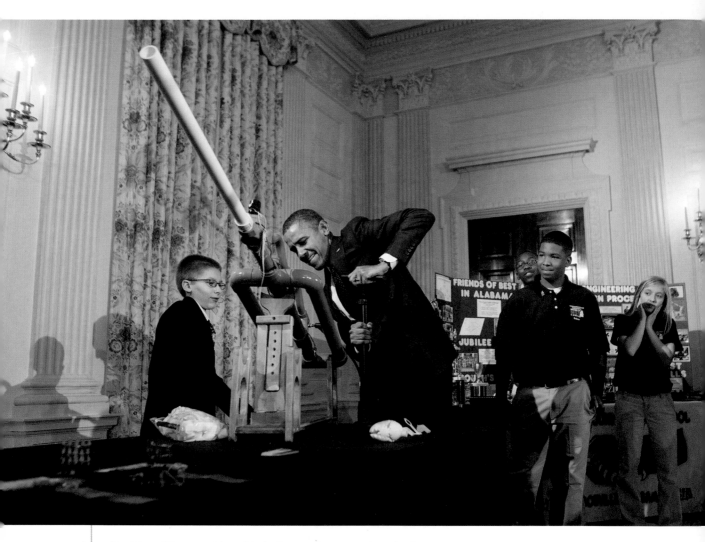

President Obama and Joey Hudy, fourteen, prime a launch of
Hudy's "extreme marshmallow cannon" in the State Dining Room
at the annual White House Science Fair, February 2, 2012.

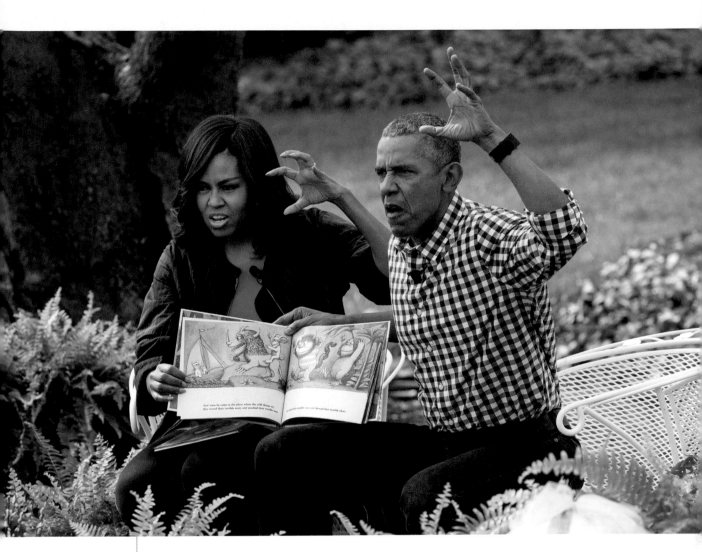

The First Couple reads *Where the Wild Things Are* by
Maurice Sendak to children during the annual Easter Egg Roll
on the South Lawn of the White House, March 28, 2016.

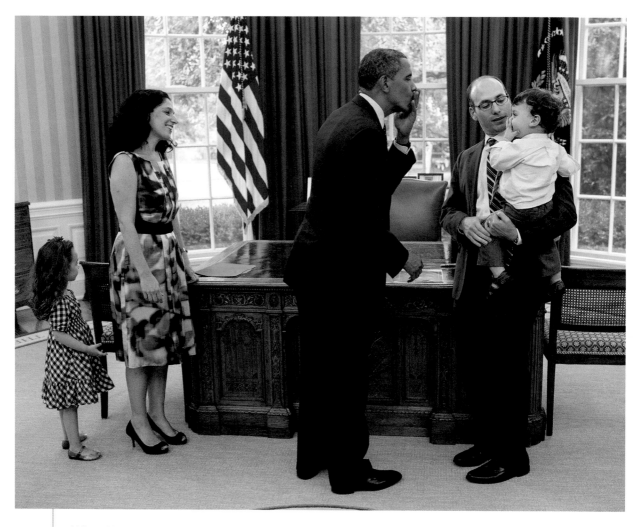

White House staffers often said that when the President's spirits needed lifting, it was time to bring in some small children. Here, President Obama blows a kiss to Oren Baer, son of Ken Baer, the departing Associate Director for Communications and Strategic Planning at the Office of Management and Budget during a visit to the Oval Office, July 12, 2012. Baer's daughter, Avital, and wife, Caron Gremont, watch at left.

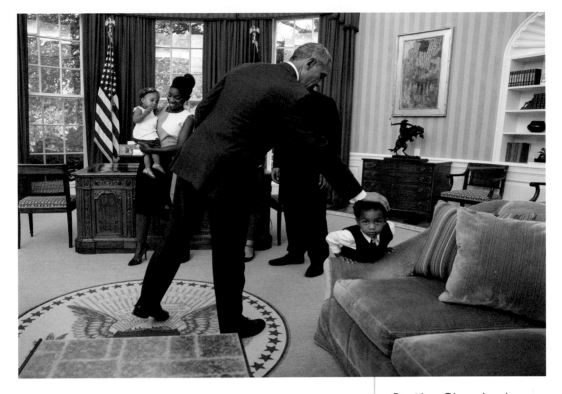

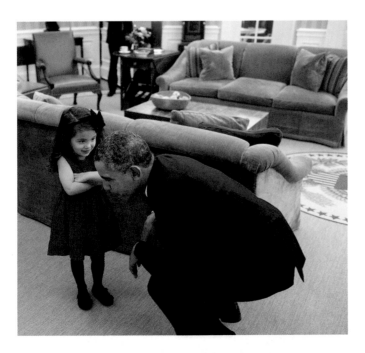

President Obama has departure photos taken with National Security Council staffer William Campbell and his family in the Oval Office, July 6, 2016.

LEFT: President Obama bends down to listen to the daughter of a departing U.S. Secret Service (USSS) agent in the Oval Office, October 28, 2013.

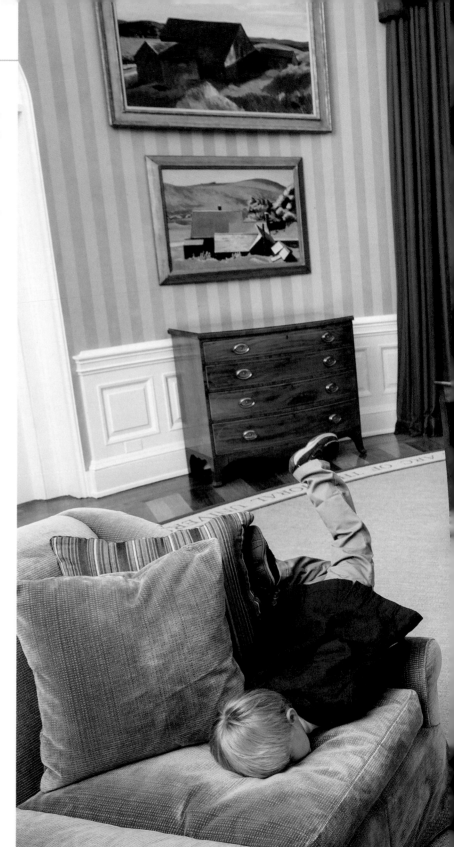

USSS agent Mike Ross and his wife, Leanna, chat with President Obama while their son Barrett does a face-plant into the sofa in the Oval Office. This picture got more than a million hits on the White House Flickr site in its first twenty-four hours of being posted.

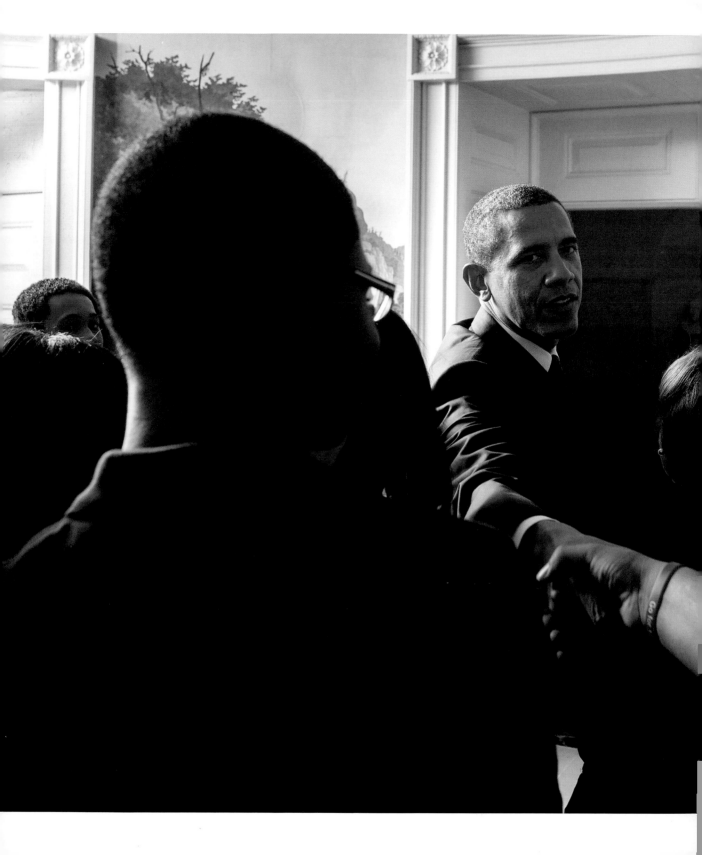

President Obama greets the students of Johnson Preparatory School of Chicago before taking a group photo with them in the Diplomatic Room of the White House, October 28, 2011.

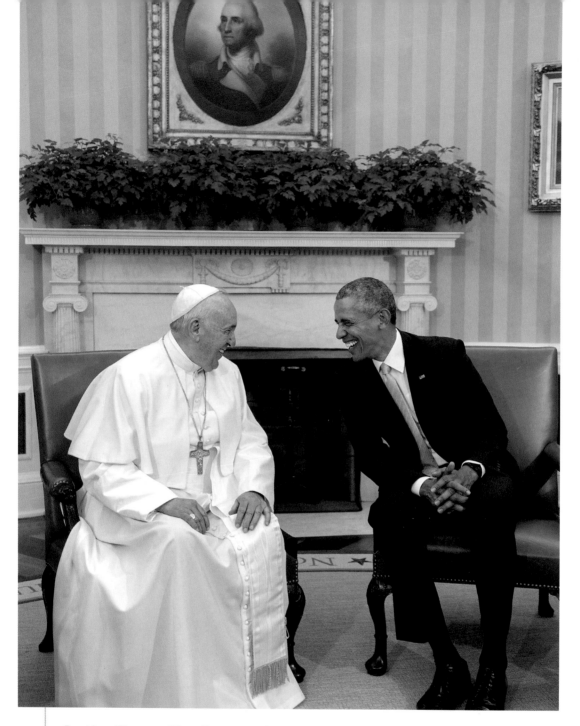

President Obama and Pope Francis are photographed by the press pool prior to a meeting in the Oval Office, September 23, 2015.

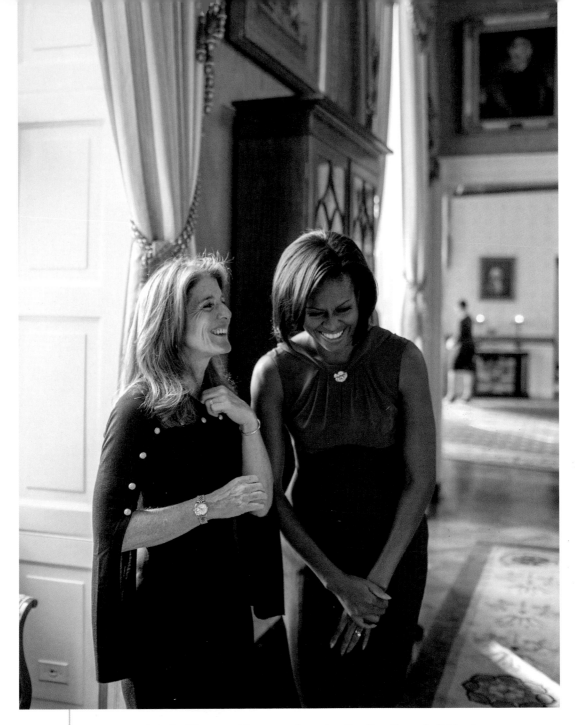

First Lady Michelle Obama and former ambassador Caroline Kennedy Schlossberg
share a laugh in the Green Room of the White House before being introduced
into the East Room for a celebration of the fiftieth anniversary of the White
House Historical Association, October 31, 2011.

PICTURE PERFECT

"Is there anything we should know before he gets here?" asked a visitor, who was a bit nervous, before their group shot with President Obama in the Blue Room of the White House. It was a common question asked by people who were just otherwise excited at meeting and having their picture taken with President Obama or First Lady Michelle. I usually tried to allay such fears by reassuring visitors that the President and First Lady were the most down-to-earth people they would meet.

But occasionally, I liked to have a little fun with the people who were so worked up and nervous. They needed a little levity. "Whatever you do, don't look them in the eye," I'd say with a straight face. "And if your hands are sweaty or clammy, offer a fist bump instead of a handshake." If that didn't make them smile or put them at ease, then nothing would.

Over the years of doing group shots and photo lines, I've seen just about everything—the overly excited, the sublimely subdued, the fast-talkers who have something to get in before being pulled by the social military aide, and the people who try to distinguish themselves from everyone else in the photo line. The best one I ever witnessed was when a couple handed President Obama their camera and asked him to take their picture. ∎

President Obama takes a picture of guests Marilyn Arleen Nelson and Glen D. Nelson during the Kennedy Center Honors reception in the Blue Room of the White House, December 4, 2011.

NO FILTER

As a photographer, I'm always watching and reading people—not just the principals but the reaction shots too. And nothing compares to watching people lose their minds when President Obama or First Lady Michelle walked into the room (especially when unannounced). The reactions were always honest—raw and uncensored, full of emotion. There was no filter, just gasps, screams, tears of joy, jumping up and down, and sometimes disbelief that they were actually in the same room with them. I always loved capturing these moments, because I felt that awe and emotion myself. ▪

High school students of Asomugha College Tour for Scholars (ACTS) react to seeing First Lady Michelle Obama arrive for a surprise visit in the Diplomatic Room of the White House during their tour, April 8, 2015.

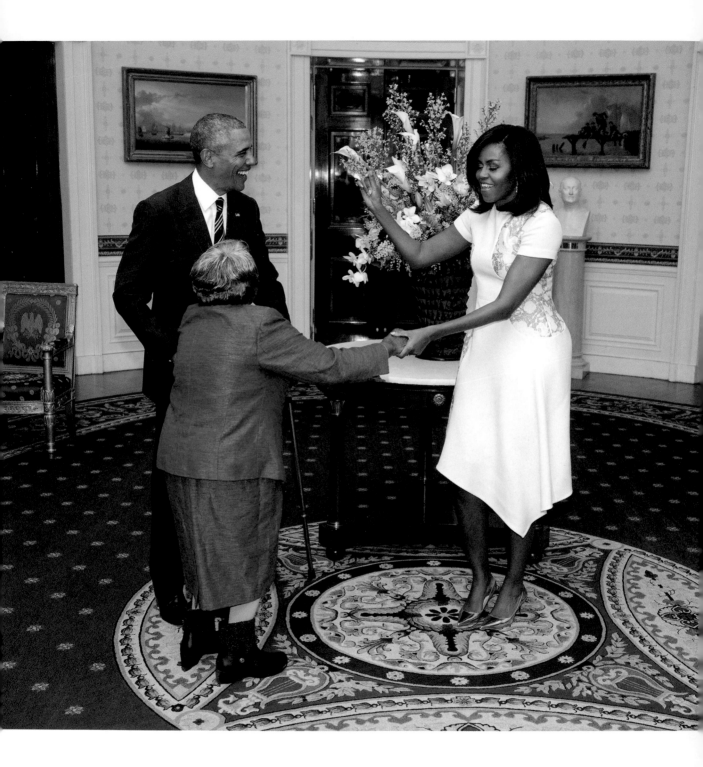

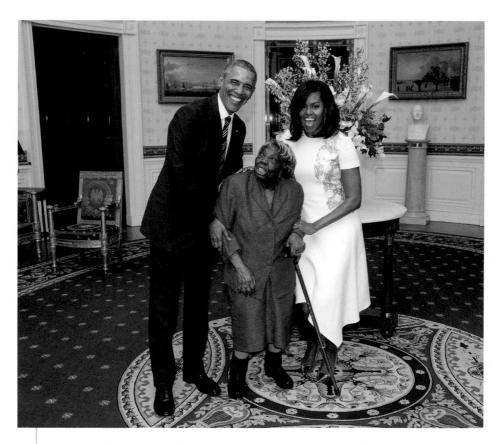

The First Couple greet 106-year-old Virginia McLaurin in the Blue Room of the White House prior to a reception celebrating Black History Month, February 18, 2016.

MOMS GET A KISS

Sometimes when the president travels to different cities there's an opportunity for White House staffers with family members living locally to meet him. It was on such a trip to Richmond, Virginia, my hometown, that my family got a chance to meet President Obama backstage before he gave his remarks at the University of Richmond. It was my older sister (Veronica), brother (Jay), niece (Nicole), and mother (Arlene). I've watched the President work a room a hundred times, but it's different when it's your family. The pride I felt as these worlds came together was beyond words. He shook everyone's hand, and when he got to my mom, he gave her a kiss. "Moms get a kiss," he said. The whole interaction lasted less than a minute before they were rushed to their seats and I went to my position to cover the speech.

My mom is not the type of person to draw attention to herself or brag about meeting the President. But even she told immediate family and friends and had several copies made of the group photo we took together. She's always been proud to see an African American become president of the United States—something she never expected to see in her lifetime. But she's even prouder to know that, regardless the color of his skin, he's "a good and decent man."

The very next day we were back at the White House and I was walking into the Oval Office to set up a light for a round of photos. The President was behind the Resolute Desk as he noticed me with all my gear. He looked up and said, "Lawrence, I really enjoyed meeting your family yesterday." I said, "Thank you, sir, but the honor was all theirs."

Every time I tell this story I get a little emotional because it almost feels like it's come full circle. Here is the first African American president, a kind and generous man who gave my mom a kiss on her cheek. And my mother, the woman who scrimped and saved to buy me my first camera, which set me on a path to eventually become a White House photographer. Too often we see only one side of the experience—the everyday citizens meeting a president or First Lady—with all the excitement that comes with it. But to see the other side, when President Obama took the time to mention my family the next day, is a small moment that speaks volumes and sets him apart. ∎

President Obama greets my family before a rally in Richmond, Virginia, September 9, 2012. *(Official White House Photo by Pete Souza.)*

President Obama jokes with departing staff member Ruchi Bhowmik and her family in the Oval Office, July 12, 2013.

FOLLOWING PAGE: President Obama poses in a group selfie with the United States Women's National Soccer Team after their victory in the 2015 FIFA Women's World Cup, in the East Room of the White House, October 27, 2015.

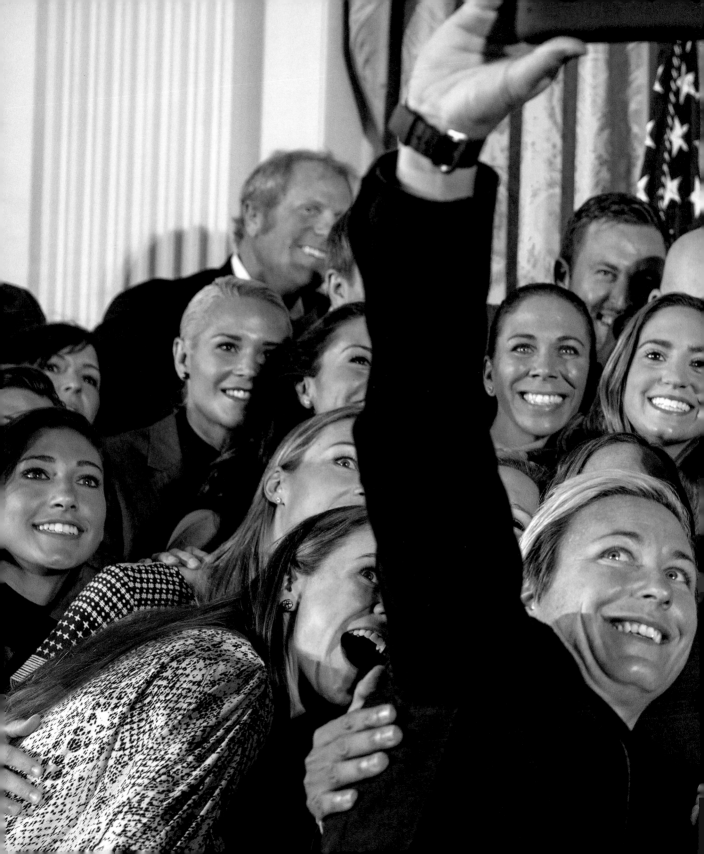

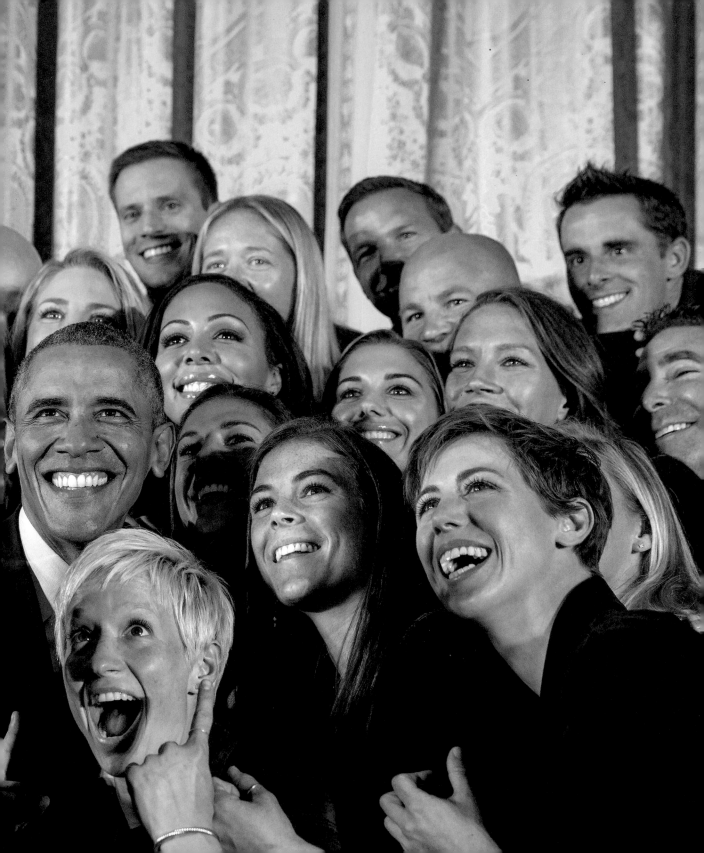

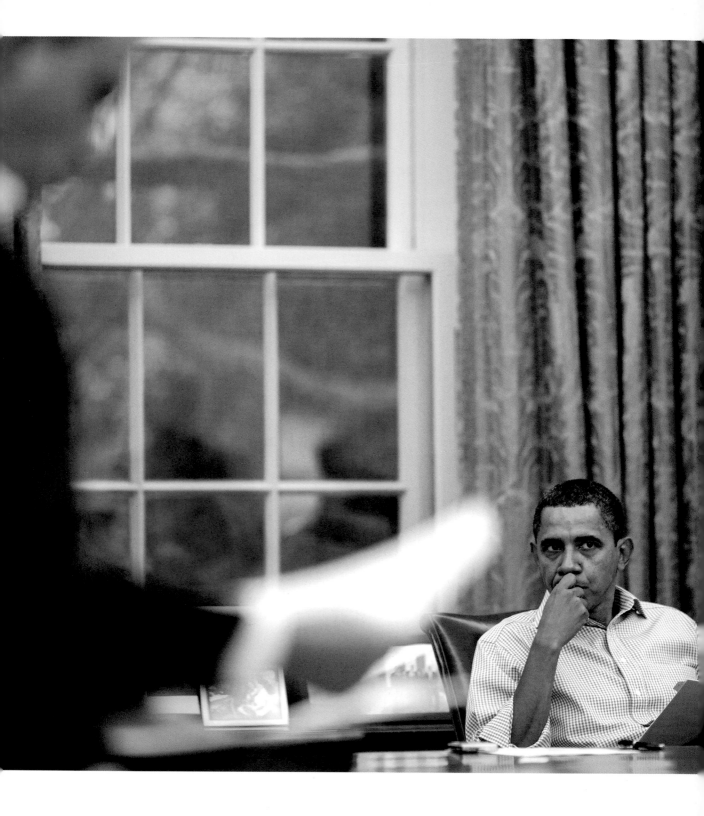

TEAM
PLAYERS

The people I worked with at the White House came from a kaleidoscope of backgrounds and experiences. Yet we came together in pursuit of a common cause. When hands were busy, heads were down, and everyone was doing their part in making the whole—keeping President Obama and his agenda on task, on message—it was an amazing feeling of connection and purpose. From the Secret Service agents, speechwriters, volunteer motorcade drivers, White House butlers, Air Force One crew members, interns, advance travel associates, Legislative Affairs team, East Wing staffers, White House Social Office, stenographers, press wranglers, White House staff secretaries, and even us photographers—we worked long days and slept short nights, but it was always worth it.

President Obama listens to his National Security Council staff in the Oval Office before phone conversations with world leaders, October 24, 2009.

Sharing laughter and sometimes shedding tears with these co-workers was a bond I'll never forget—and one I didn't realize I'd miss or appreciate as much as I do until it was over.

I first got a sense of the passion and focus of Team Obama before the 2008 election, when reporter Liz Sidoti and I worked on a story for the Associated Press on the campaign staffers for both McCain and Obama just six weeks before election day. While the unpaid volunteers on both sides were courteous and polite and believed in their candidate, the energy around then Senator Obama's campaign was truly next-level. There were people from varied backgrounds, from different ages, ethnicities, and income levels, working together to get the word out about their candidate. The D.C. area was so saturated with Obama volunteers that they organized busloads of people to ride down to Richmond on Saturdays to help canvas the suburbs there. People were taking time off work or devoting their weekends to help elect the first African American president of the United States. I came away from that assignment thinking their inspiration was deeper and more pervasive than that of any other campaign I'd ever covered.

In truth, I just wanted to take pictures of the first African American president. As a photojournalist I wasn't trying to save or change the world, just take compelling pictures to tell a story of this historic time in our country. I didn't know Senator Barack Obama, the Democrat from Illinois. But I had a feeling about him, as did a lot of people who signed up to work the campaign and, after that, to be a part of the Obama administration. Some people thought it was crazy for me to leave a good job at the Associated Press. But I wasn't the only person who took a chance on Barack Hussein Obama.

Take Eric Waldo, a recent law school graduate who turned down a high-paying job as a lawyer to be an unpaid legal intern for the Obama campaign in 2007. After the election, with his law degree and master's in education in hand, Eric started working for the Department of Education as Special Assistant to Secretary of Education Arne Duncan. In five years Eric made it to Deputy Chief of Staff before moving over to run Reach Higher, First Lady Michelle Obama's higher-education initiative. Inspired by

the book *The History of American Education*, Eric loved how people like Thomas Jefferson and Horace Mann championed the creation of "common schools," which were the precursor to modern public schools. Eric, like President Obama, First Lady Michelle, and a lot of other people, believes that an education is "the great equalizer" that can pave the way to healing many of society's troubles.

Edith Childs might not be a household name, but she's the remarkable woman who came up with the famous campaign phrase "Fired Up! Ready to Go!," energizing the 2008 campaign during the Democratic primaries in South Carolina. She said, "I always felt, I knew at some point we'd have a black president, but I thought it'd be way down the road. I even said it when he first ran—he laughs about it now—I thought, 'Hm, I'll be dead and gone before it happens.' . . . There was just something about him. I said that he was going to be our next president. He went above and beyond my expectations. I think that he will go down as one of the best presidents that the United States has ever had."

Even today, when I run into a former Obama staffer, there's an instant connection, a familiarity of an old friend that's hard to put into words.

When addressing the staff, President Obama often talked about what "we are doing." He was always inclusive, ready to share the successes of his administration but accepting full responsibility for the failures. He inspired a passionate and loyal team committed to helping our country find its best self.

> "I SAID THAT HE WAS GOING TO BE OUR NEXT PRESIDENT. HE WENT ABOVE AND BEYOND MY EXPECTATIONS. I THINK THAT HE WILL GO DOWN AS ONE OF THE BEST PRESIDENTS THAT THE UNITED STATES HAS EVER HAD."

"President Obama was good at keeping things light, even when we were discussing weighty topics, or disagreeing with one another on tough policy decisions. He was especially good at acknowledging—and calming—the very visible nerves that people displayed in his presence, especially people who were meeting him for the first time.

I especially appreciated this quality the very first time I walked into the Oval Office. For more than eight years I was in that office countless times, and it never failed to give me a shiver of disbelief. But the very first time you walk in isn't just awe-inspiring, it's paralyzing. I thought my heart might stop beating. The paralysis hit just before I walked through the door; I simply stopped moving. He kind of chuckled and waved me in, standing up and coming to meet me, to make me feel at ease. He knew what I was there for, and started the conversation instead of waiting for me to dive in, probably to keep me from stammering. One after another, he found ways to make his team feel at ease, which, when you think about it, is remarkably generous for someone who has the weight of the world on his shoulders.

–CECILIA MUÑOZ, former director of the White House Domestic Policy Council

"My first impression of Barack Obama when we met in July 1991 was that both he and his fiancée, Michelle Robinson, wanted to commit their lives to public service, but they were searching for a more effective way to do it. The dinner came about because he had reservations about Michelle joining the Daley Administration and he wanted to better know the person who would be her boss, to test his comfort level. He asked me a range of questions, from what my early life was like living in Iran until I was five, to why I had left a big law firm and joined city government. He told me about his childhood in Indonesia and his search for how best to apply his talents. We realized that we had a lot in common in terms of how those early experiences shaped our worldview and our determination to use our education to be forces for good.

He has certainly grown and matured over the last twenty-eight years since we met, but as Michelle Obama said at the Democratic Convention in 2012, being President did not change Barack Obama. It simply revealed who he is. What I find striking is that notwithstanding all of his years in the rough-and-tumble world of politics, he still has an optimistic outlook and searches for the good in people.

–VALERIE JARRETT, former White House Senior Advisor

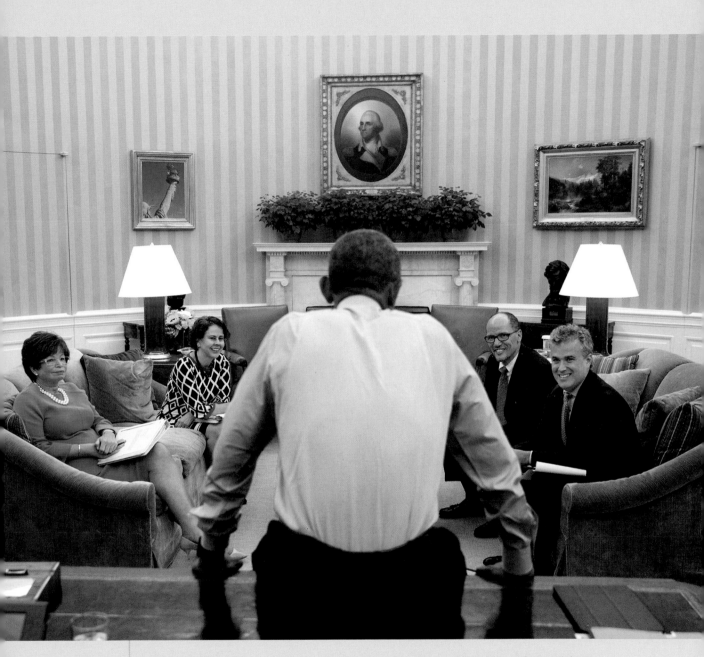

President Obama meets with Secretary of Labor Tom Perez, White House Senior Advisor Valerie Jarrett, Director of the National Economic Council Jeff Zients, and Director of the Domestic Policy Council Cecilia Muñoz in the Oval Office, July 22, 2015.

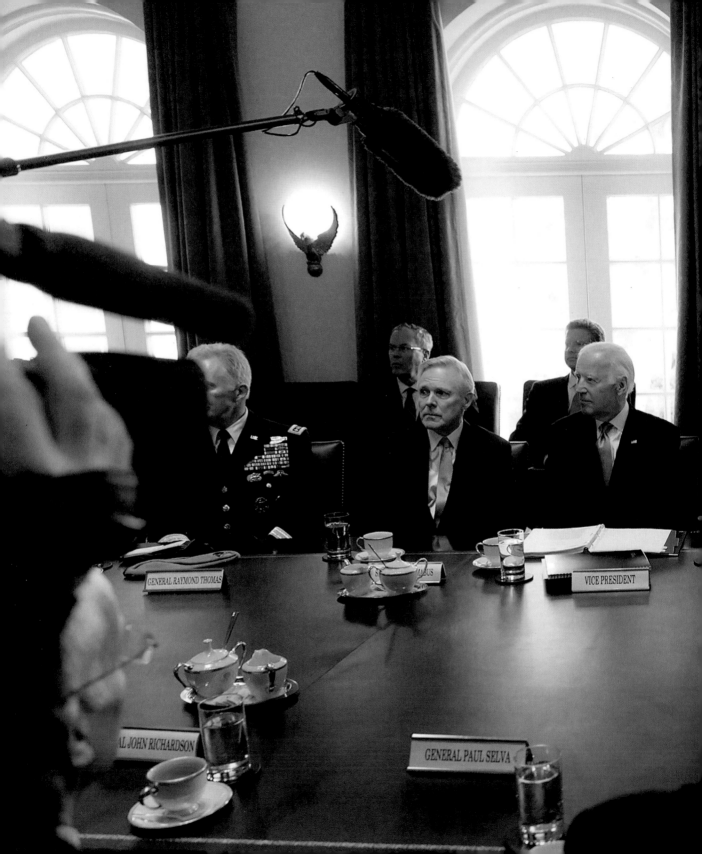

GENERAL RAYMOND THOMAS

VICE PRESIDENT

AL JOHN RICHARDSON

GENERAL PAUL SELVA

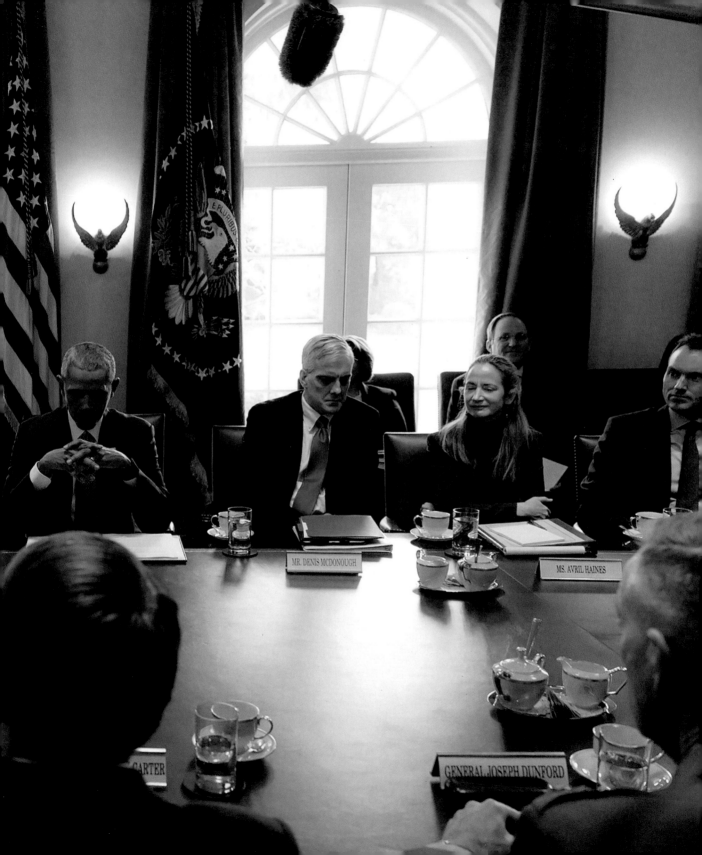

MR. DENIS MCDONOUGH

MS. AVRIL HAINES

CARTER

GENERAL JOSEPH DUNFORD

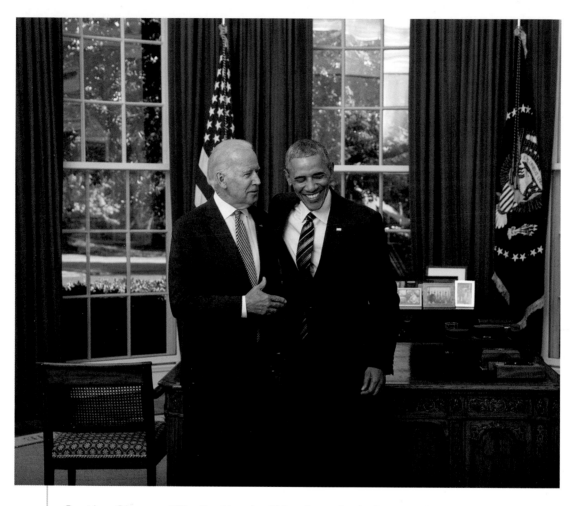

President Obama and Vice President Joe Biden share a laugh prior to a photo line with appointees in the Oval Office, June 13, 2016.

PREVIOUS PAGE: President Obama pauses after delivering a statement to the press prior to a meeting with the Joint Chiefs of Staff and Pentagon leaders in the Cabinet Room of the White House, January 4, 2017. I was often struck by the focus and preparation the President brought to working sessions of all kinds.

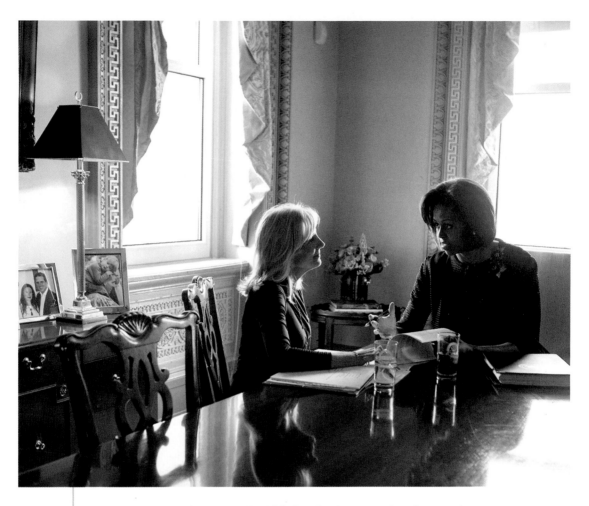

First Lady Michelle Obama and Dr. Jill Biden chat between takes during a photo shoot and interview with *AARP* magazine in Dr. Biden's office in the Eisenhower Executive Office Building, May 6, 2011.

KEEPING UP WITH POTUS

"Have you had your first anxiety dream yet?" was the question I asked Amanda Lucidon, our latest hire in the White House Photo Office under the Obama administration. She had been on the job a few weeks and looked at me quizzically. "No," she said, but I knew that eventually she would, because we all had them at some point during our time there. It was the nature of the beast. Getting the picture, being ready for any and every situation that comes up. Things happened fast, and the last thing you wanted to do was hold up the President, Veep, or any dignitary because you weren't ready to take a picture. "Can you do a thirty-person group shot real quick?" they asked with a straight face. The answer was usually yes, but perfection on such short notice was a journey, not a destination.

My anxiety dreams surrounding work were always about being late, running out of space on my compact flash cards, or just plain missing the shot involving the President or First Lady during an event. Nothing as bad as those dreams ever happened, but I think they gave me a healthy dose of fear to make sure they didn't. I did miss a motorcade for a golf outing once. There I was, walking down the West Colonnade as I watched the motorcade pulling away on the South Lawn driveway. I wasn't late for the departure—POTUS was just eager to go, so he left fifteen minutes early. I got in my car and drove to Joint Base Andrews Golf Course and met them there. I missed the first hole of golf.

A month or so later, Amanda walked into the office one morning and declared, "I had my first anxiety dream!" She was in a swimming pool with her cameras above her head trying to get out as she watched First Lady Michelle walk by, headed to her next event. Like I said, it comes with the job. ■

President Obama boards Air Force One at Joint Base Andrews, May 1, 2010.

FOLLOWING PAGE: White House staff and travel pool board Air Force One at Boeing Field / King County International Airport for departure from Seattle, Washington, en route to San Francisco, California, July 22, 2014.

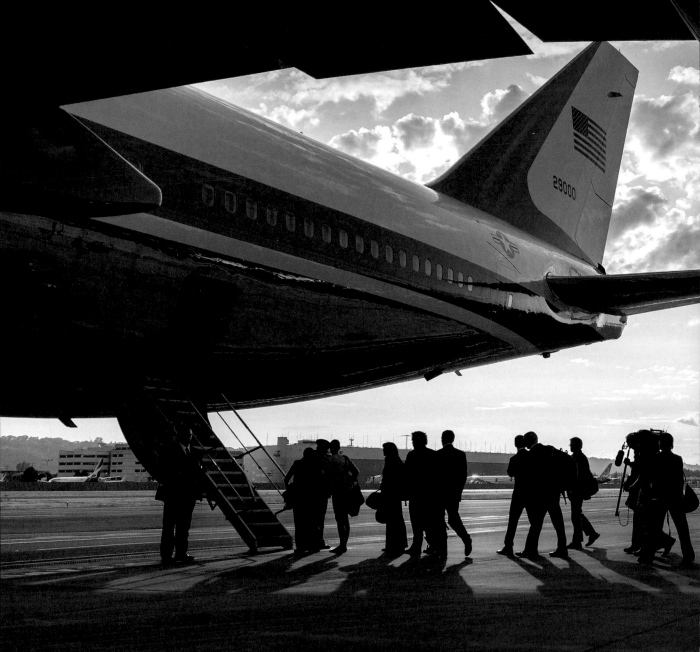

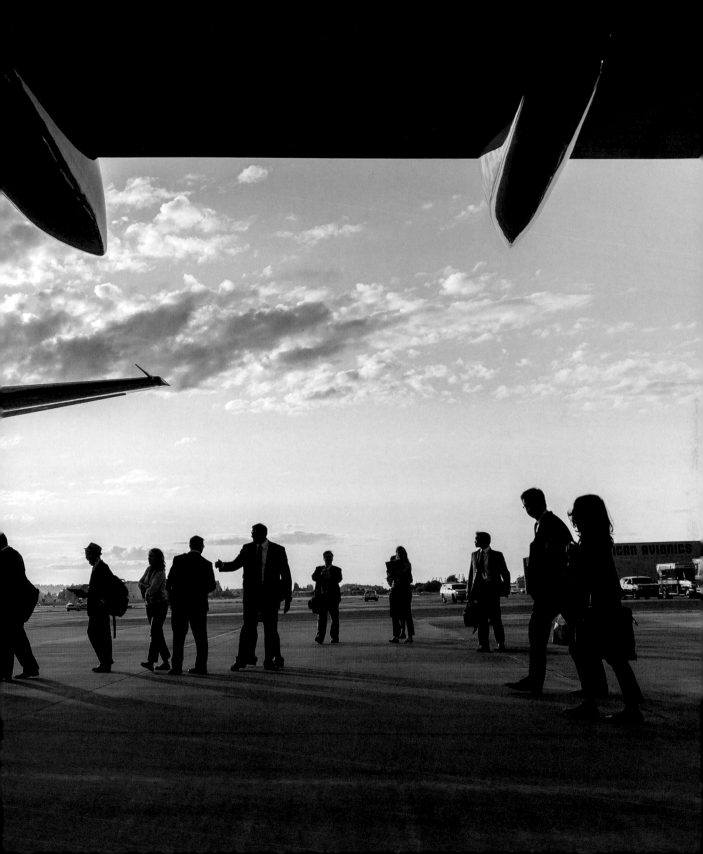

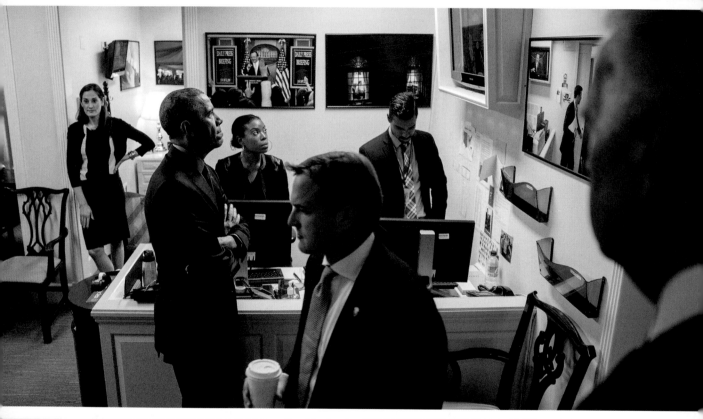

THE CAPTURE OF DYLANN ROOF

Watching the four split-screen televisions outside the Oval Office, I knew things were about to get busy. The networks were all carrying the breaking news on the capture of Dylann Roof, the lone gunman who murdered nine African American churchgoers in Charleston, South Carolina. I was the primary photographer because White House Chief Photographer Pete Souza had departed for Joint Base Andrews ahead of the President. It was rare to see the President dealing with a breaking news situation. Things started to get busy—people coming and going and the phones ringing. For a brief moment I thought about the church members who were killed and how Charleston is an old Confederate city just like Richmond, my hometown. And how my mom and some family members are regular churchgoers who attend gatherings like Bible study. The tragedy felt epic and at the same time close to home.

President Obama was briefed by Assistant to the President for Homeland Security and Counterterrorism Lisa Monaco about the details of Roof's capture and worked with White House Director of Speechwriting Cody Keenan to craft a response. The President, soon joined by Vice President Biden, moved to the White House Lower Press Office to give a statement to the press. His tone and mood were somber and businesslike. But honestly, I think after the Newtown shootings of 2012 he'd become a bit shell-shocked to the news of these shootings. They were beyond comprehension, beyond words.

He was once asked during an interview if anything shocked him anymore as president. He said, with an almost sad reluctance in his voice, that after a few months of receiving the Presidential Daily Briefing—the top-secret developments breaking around the world—not much shocked him. Because once you see and hear the terrible things people have done to one another, you can never go back. ■

DEEP IN THOUGHT

I've done something wrong, I worried to myself, based on the way the President was looking at me. In the early days of the administration, President Obama probably didn't remember my name. But with so many new staff faces, it was understandable. "What are you doing? And why are you doing it that way?" were what his eyes were saying to me. *Maybe I took a bad picture of him and it's hanging as a jumbo print in the West Wing and he's trying to see past me and my mistake.* I know it sounds crazy, but that's what was going through my mind in the beginning.

But in truth, his distant stares were never about me, or any of the other White House staffers who felt the same way I did. When you are president of the United States, the leader of the free world, you have *a lot* on your mind at any given moment. Yet you have a packed schedule—going from event to event and trying to meet the demands of each one. One moment he was in a highly classified meeting in the Situation Room, where he was getting briefed on top secret information, and fifteen minutes later he was meeting with Teachers of the Year in the Oval Office.

After a while I realized that his quiet, neutral gaze was because he was processing whatever pressing issue was before him. Whether it was the top secret meetings on finding Osama bin Laden, the healthcare overhaul, a gushing oil spill in the Gulf of Mexico, or dealing with the Ebola crisis, his plate was constantly full. But he always carried his presidential responsibilities with grace, whatever the situation. And soon enough you'd see his signature smile and warm, open demeanor once again. The saying "Act like you've been here before" often came to mind. The President had a way of seeming like he'd been there before—and drawing you into the moment too. ▪

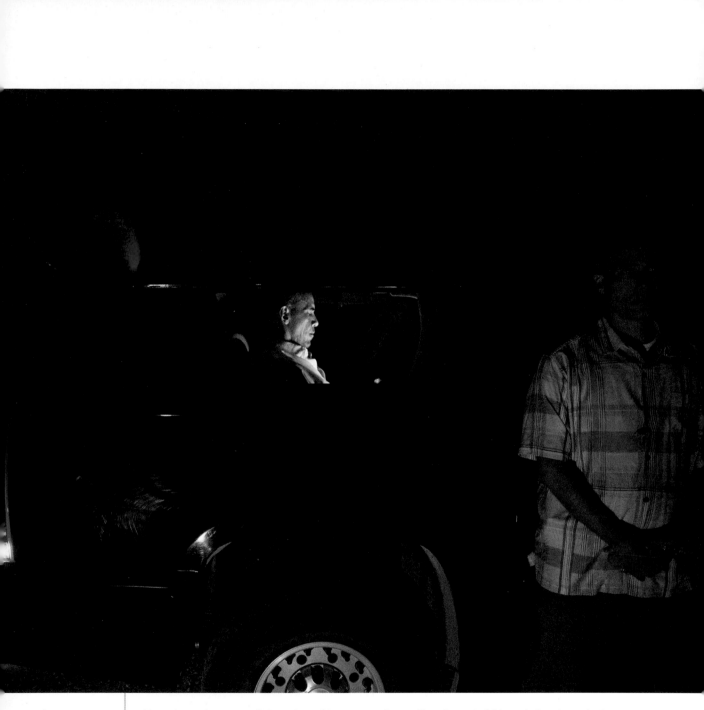

Even during his time off, President Obama was often in "work mode." Here, he's in his vehicle after having dinner at the State Road restaurant with First Lady Michelle and friends while vacationing in West Tisbury, Massachusetts, August 9, 2016.

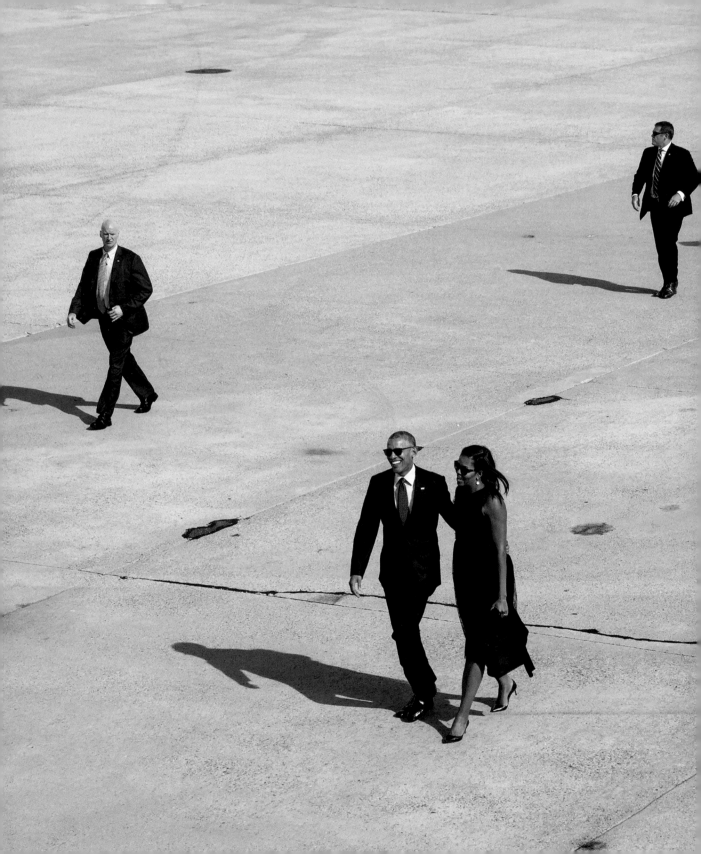

The First Couple walk across the tarmac to board Air Force One at John F. Kennedy International Airport for departure from New York, New York, en route to Joint Base Andrews, Maryland, September 21, 2016. They had just wrapped up their last United Nations General Assembly trip as President and First Lady.

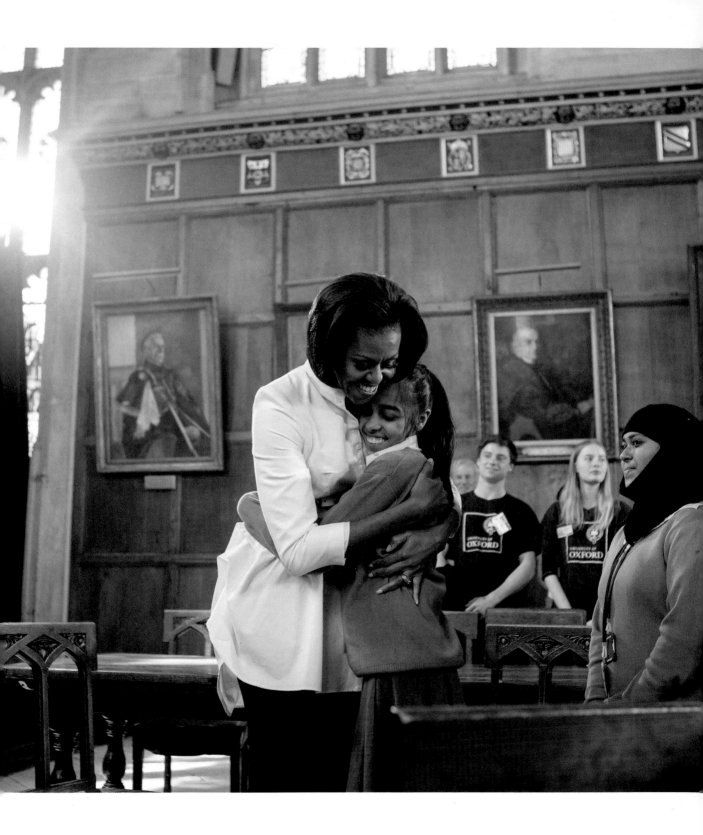

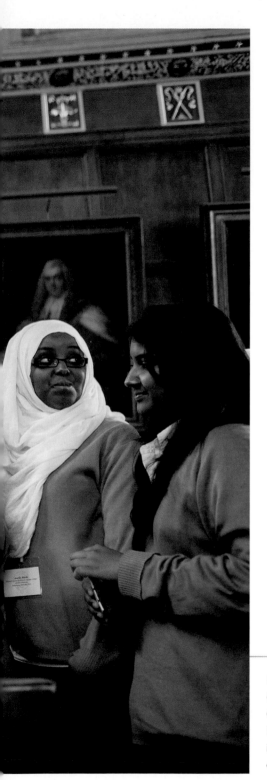

THE FIRST LADY

I t was April 2009, First Lady Michelle Obama's first overseas trip to London with the President for a G20 Summit, and I was assigned to cover her and all her separate events from the President. Her itinerary included tea with the British Prime minister's wife, Sarah Brown, and visits to Maggie's Cancer Caring Centre and Elizabeth Garrett Anderson School. There was great excitement—the world was ready to receive the new Obama administration.

It was at the all-girls school where I got the first glimpse of the emotion and passion the First Lady has for kids—and particularly for young girls. After their performances in music, interpretive dance, poetry reading, and theater, the First Lady gave her remarks

First Lady Michelle Obama hugs every student at Elizabeth Garrett Anderson School after delivering remarks to them at Christ Church College at Oxford University in Oxford, England, May 25, 2011. Mrs. Obama cited the school, whose students include many refugee children, as the inspiration for her focus on education during her time at the White House.

to the audience. The secondary-school girls, in their brown-and-pink school uniforms, cheered but listened intently to her every word. "Nothing in my life's path would have predicted I'd be standing here as the first African American First Lady of the United States," she said. Her emotions would come to the surface as her voice cracked a few times during the speech. Everyone could tell how touched she was by the girls and their appreciation of her. It was then and there that I became one of her biggest fans.

The years that followed only solidified that view. My observations of her up close have consistently shown her trying to help those in need by making things better. She has a fierce loyalty—to family, friends, and staff—and heartfelt connections to people she's met around the world. It's one of her qualities I admire the most. And after having a front-row seat to her remarks for eight years, I can say that she gave a piece of herself every time she spoke.

Students sing a song for the First Lady as she visits and tours Burgess-Peterson Academy in Atlanta, Georgia, February 9, 2011.

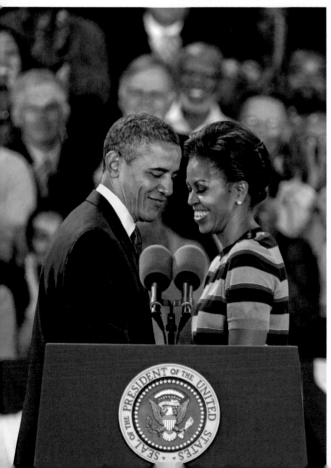

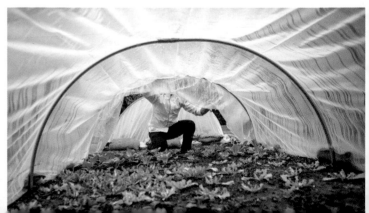

"This moment was like so many we had in the White House, the quiet just before the First Lady was about to go onstage, and the amount of preparation that she put in to every one of those appearances. On this particular day, as we waited for the graduates to get into place for the commencement, she wanted to take the time to review her remarks one more time, because as she always said, commencements were for the graduates and their families, and she wanted to make sure the day went just right for them. And of course, being on my BlackBerry is emblematic of so many of my hours at the White House!

—TINA TCHEN, former Chief of Staff to the First Lady

The First Lady, with her Chief of Staff, Tina Tchen, goes over the remarks of her commencement address at Virginia Tech, in Blacksburg, Virginia, May 11, 2012.

The First Lady talks with one of her high school student mentees on the East Colonnade of the White House, February 18, 2010.

"So I had this crazy idea that what if we planted a garden on the White House lawn to start a conversation about where our food comes from and how it impacts our children's health?"

—FIRST LADY MICHELLE OBAMA, OCTOBER 5, 2016, AT THE WHITE HOUSE KITCHEN GARDEN DEDICATION

GOING GREEN

I remember being given the assignment to take pictures of the White House Kitchen Garden shortly after it was created, as part of the First Lady's efforts to encourage healthy eating. When I got there, Sam Kass, the White House Assistant Chef and Food Initiative Coordinator, was tending to the garden, picking vegetables for the First Family's dinner that night. He plucked a sugar snap pea and handed it to me to taste. It was amazing how sweet and fresh it was, just off the vine. My mom grew up in rural Louisa County, Virginia, and knows her way around a garden. But since we grew up in the city, those things were not passed on to my siblings and me. Watching the garden take shape, evolve, and inspire people to take part in sourcing their own foods was a joy. And as a White House Photographer, I had a unique vantage point for viewing it— thanks to a massive ladder with an almost aerial view. ▪

With students from Tubman and Bancroft Elementary schools, First Lady Michelle participates in the spring planting session in the White House Kitchen Garden, March 26, 2012.

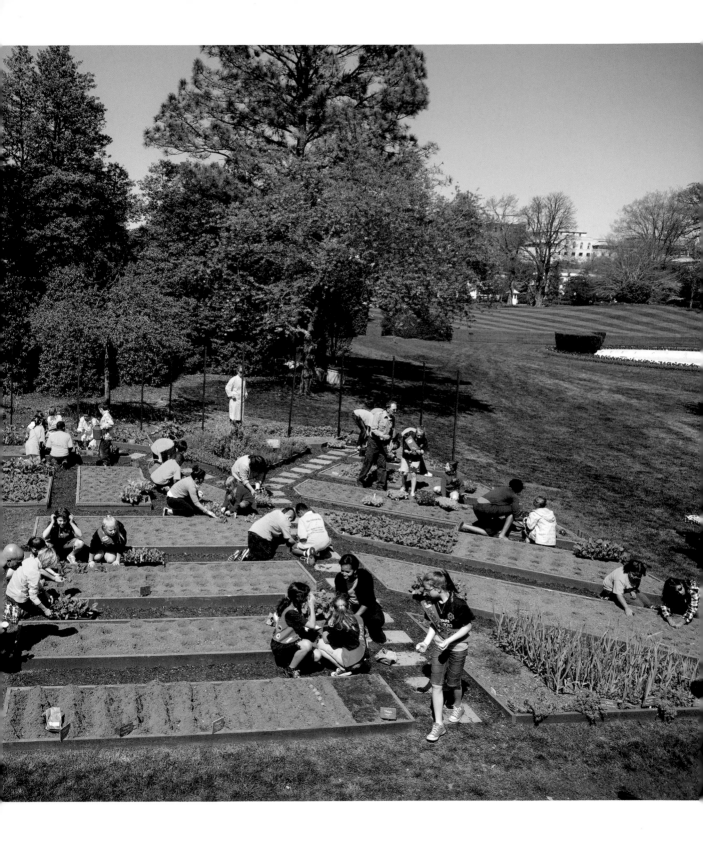

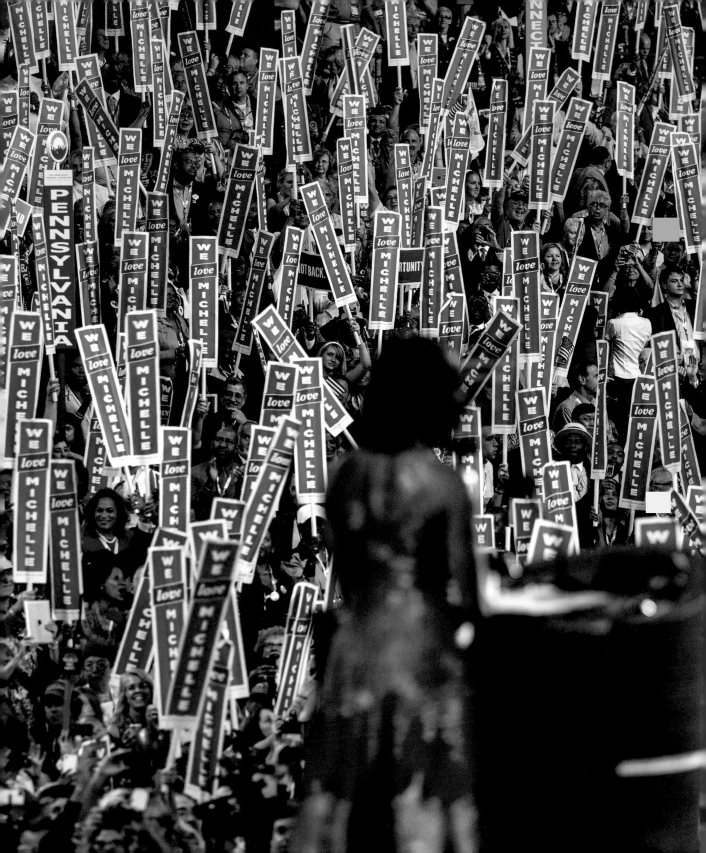

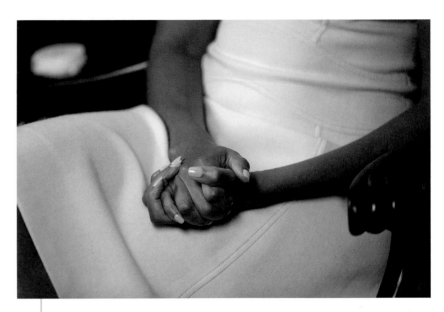

The First Lady films videos for the Abraham Lincoln Presidential
Library, Easterseals, and Joining Forces Impact Pledge in the
Map Room of the White House, May 6, 2015.

LEFT: The First Lady delivers a speech at the Democratic
National Convention at Time Warner Cable Arena in
Charlotte, North Carolina, September 4, 2012.

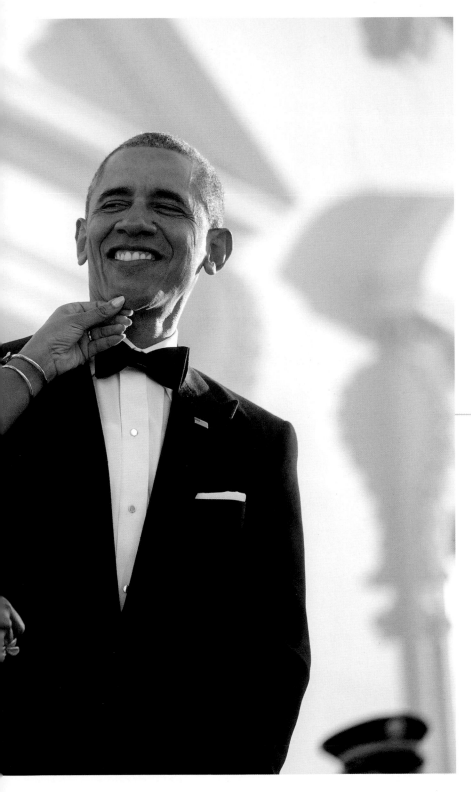

The President and First Lady on the steps of the North Portico of the White House prior to the arrivals of the U.S.–Nordic Leaders' Summit, May 13, 2016.

FOLLOWING PAGE: First Lady Michelle playfully smacks President Obama after he snuck up on her giving remarks at the going-away party for Lawrence Tucker (left), a U.S. Secret Service Agent who had been in charge of protecting Sasha and Malia, who was being assigned to a different detail. The gathering took place on May 7, 2013, in the Old Family Dining Room of the White House.

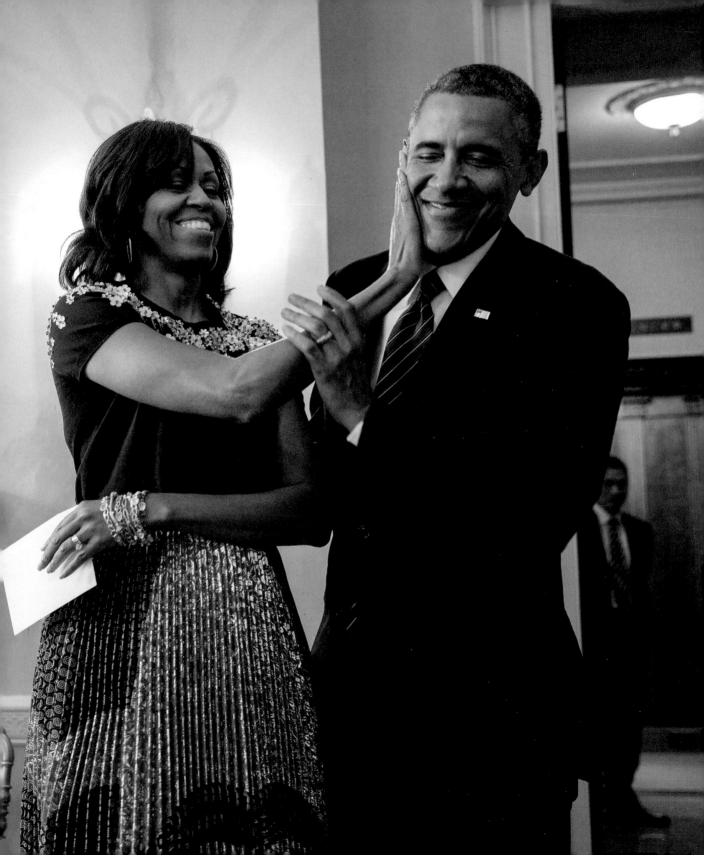

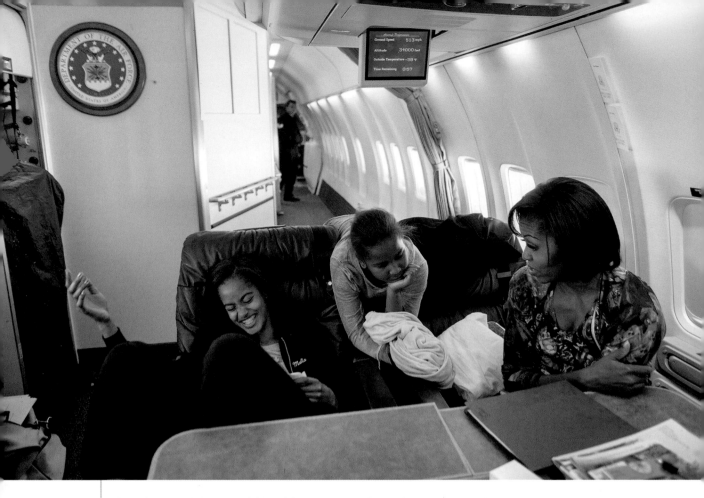

First Lady Michelle with Malia and Sasha onboard Bright Star on a trip to Los Angeles for a Joining Forces event and to make a guest appearance on the kids TV show *iCarly*, June 13, 2011.

IN THIS TOGETHER

Every holiday season the First Lady and the President would videotape a season's greeting. During the 2014 taping, they both caught a case of the giggles. It started with some tongue-tied words from the teleprompter but ended in hard-to-suppress giggles and laughter throughout the room, including us staffers—the video and lighting team as well as White House staff members and myself. The First Couple's hand-holding, fist bumps, hugs, and laughter showed they were in this together. Through celebrations and sorrows, they represented the country with class and distinction. ∎

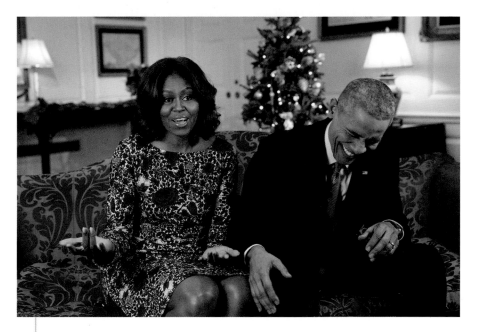

First Lady Michelle could always make the President laugh. Here, they record a joint video message to be linked via QR code on the back of the annual White House holiday card, in the Map Room of the White House, November 19, 2014.

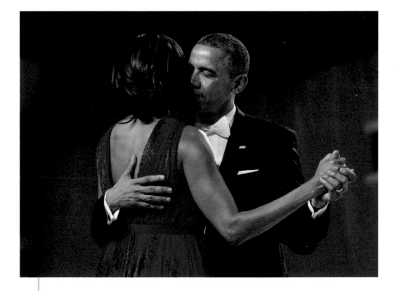

The First Couple dance together at the Commander in Chief Ball at the Walter E. Washington Convention Center in Washington, D.C., January 21, 2013.

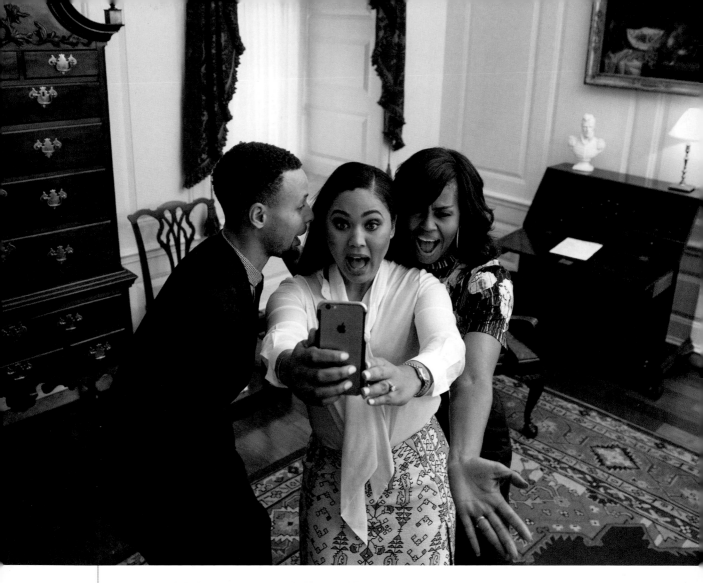

First Lady Michelle participates in a Let's Move! Dubsmash videotaping with NBA player Stephen Curry and his wife, entrepreneur Ayesha Curry, in the Map Room of the White House, February 4, 2016.

"Looking at this picture brings back incredible memories. It reminds Ayesha and me of the fun we had that day with First Lady Michelle Obama. It was our team's first visit to the White House as NBA champions, the first time our organization had achieved this feat since 1976.

It was a special moment to be working with the First Lady and her Let's Move! initiative. I don't remember the number of video takes we took, but she

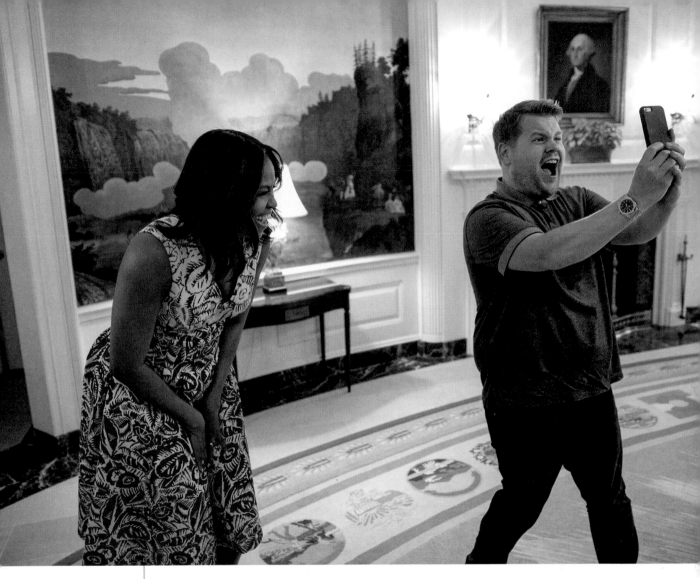

The First Lady with James Corden in the Diplomatic Room prior to a "Carpool Karaoke" taping, June 21, 2016.

couldn't have been more charismatic, funny, or laid-back. She made Ayesha and me feel welcomed and at home in the White House. As a First Lady, she set a high bar in her outreach to kids, teaching them healthier food choices, exercises to keep moving, and the importance of higher education. Undoubtedly we couldn't have been prouder of her eight years as our First Lady.

—STEPHEN CURRY, All-Star NBA player for the Golden State Warriors

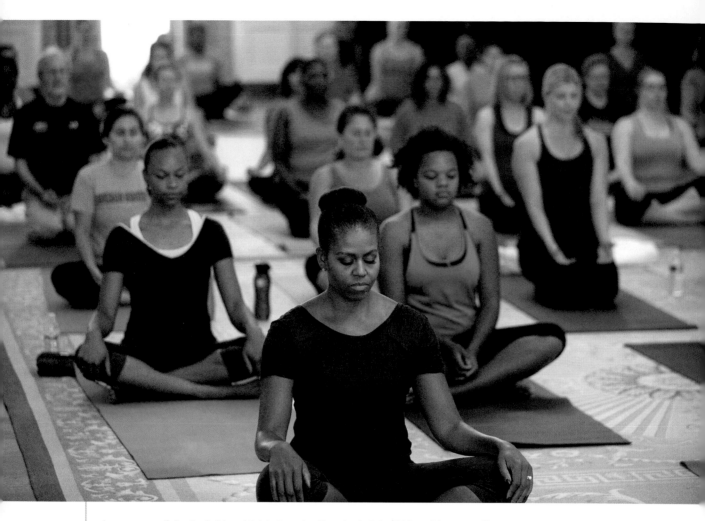

In support of the Let's Move! initiative, the First Lady joins White House staff in the East Room for a yoga event hosted by the EOP Health and Wellness Council and the White House Athletic Center, September 4, 2014.

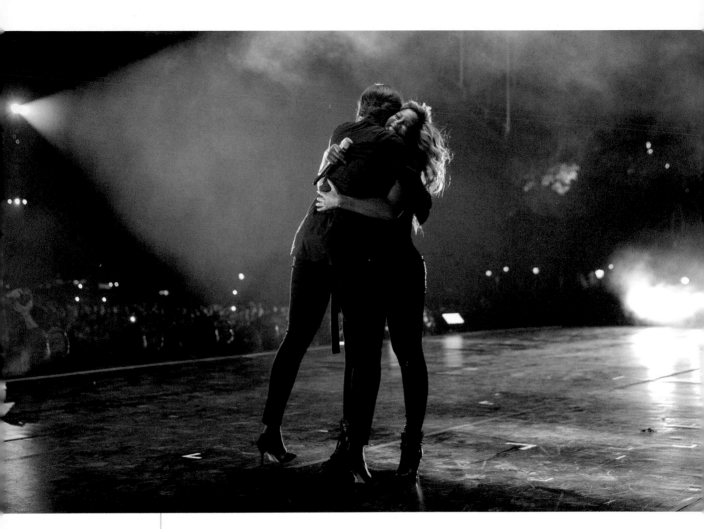

First Lady Michelle greets Beyoncé after her performance during the 2015 Global Citizen Festival in Central Park in New York, New York, September 26, 2015. The First Lady announced a new public engagement campaign hosted by Girl Rising.

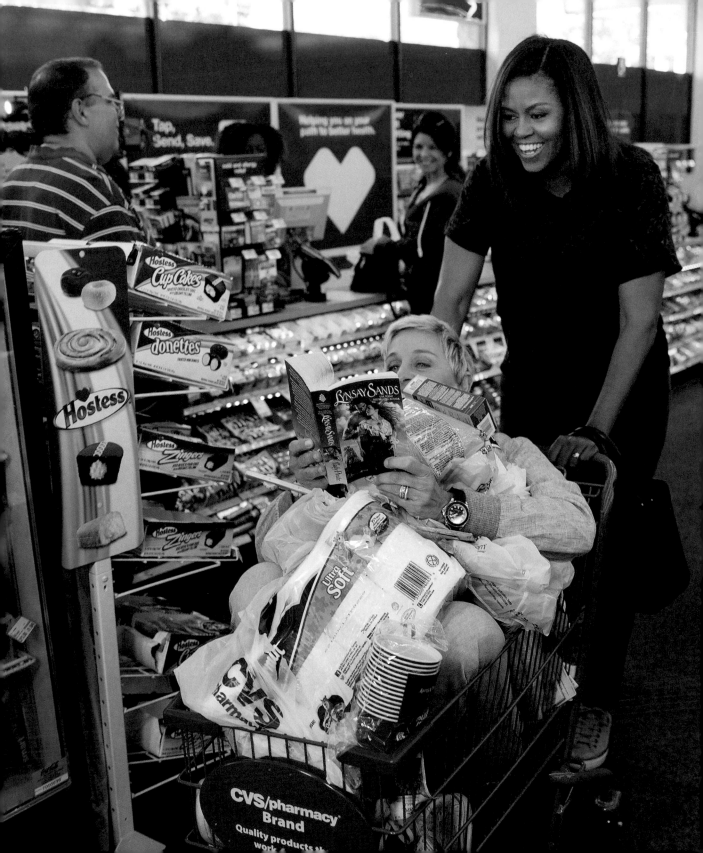

The First Lady and Ellen DeGeneres tape a skit for *The Ellen Show* at a local CVS in Burbank, California, September 12, 2016.

The President and First Lady participate in a photo shoot with Miller Mobley for *Parade* magazine in the Diplomatic Room of the White House, May 20, 2014.

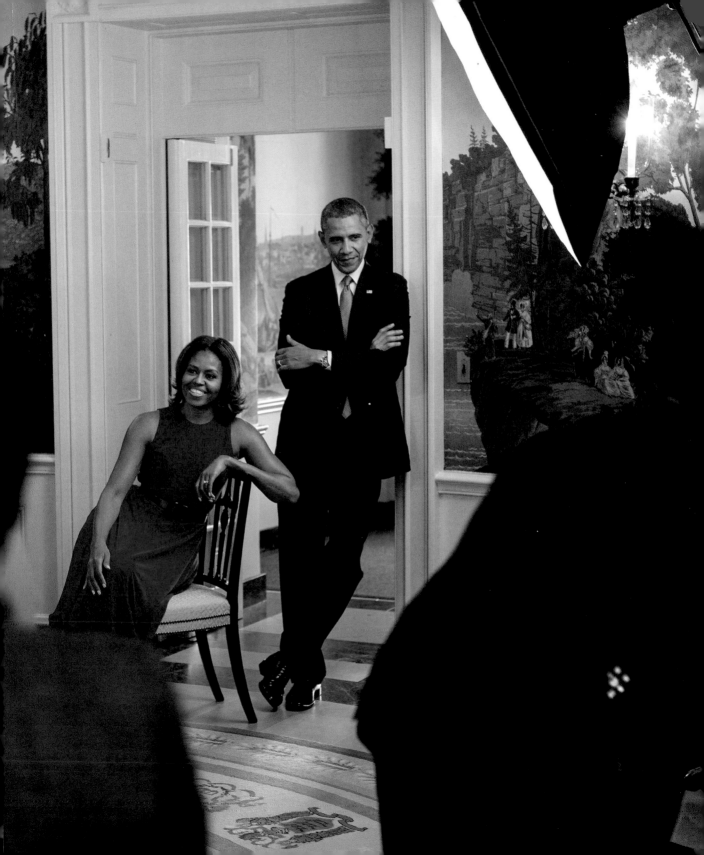

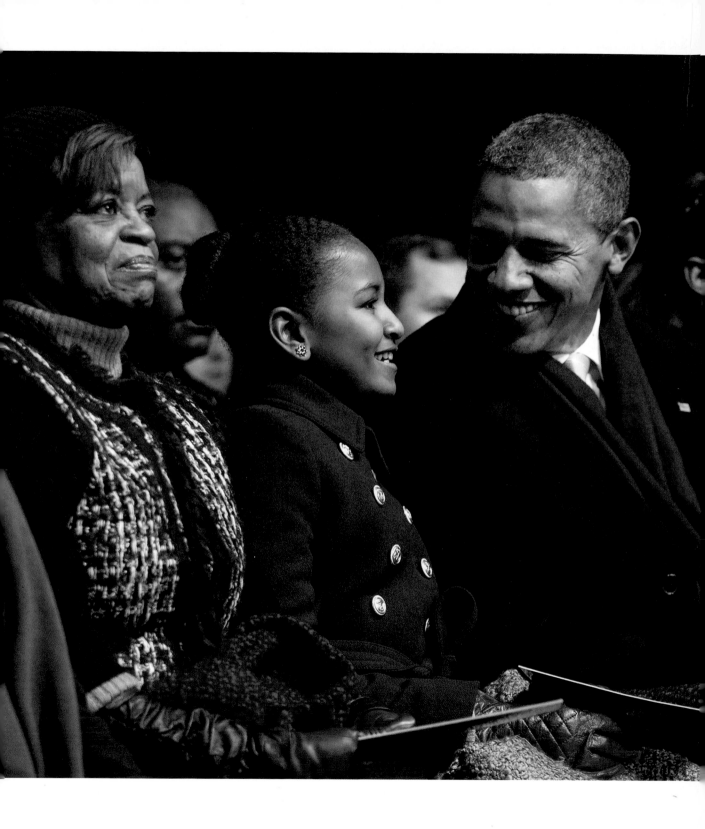

FAMILY MATTERS

January 16, 2010. The President took the First Lady out for a surprise birthday dinner with friends and family to celebrate her birthday at Restaurant Nora near Dupont Circle.

Our job, as White House photographers at these events, was to grab a few shots at the beginning of the dinner and then find a way to be seen only if the President or First Lady needed a picture taken. It was still fairly early in the first term, and the President didn't quite get why we were always around. He'd rather have nonessential staff go home to be with their families. But our directive was "We cover the President whenever he goes out in public."

The First Family—President Obama, First Lady Michelle, daughters Sasha and Malia, and Mrs. Marian Robinson—attend the Christmas Tree Lighting Ceremony on the Ellipse near the White House, December 1, 2011.

So I took a few photos of the arrival and then hid in a side room of the restaurant. As the night progressed, the President walked by on his way to the restroom and saw me in that side room. I caught his eye, and he said, "Lawrence, what are you still doing here?" I tried to remind him that I was there in case he needed a picture taken for any reason. He said, "You should be home with your family, those babies." I laughed nervously and thought to myself, *Did he just give me a direct order?* Even if he had, I had to stay. Something could have come up and he would have been called back to the White House. I needed to stay.

On his way back to the party, he motioned for me to come in to the main room to get a group shot of all the guests—as if to give me something to do. It was a clumsy shot with tough lighting, but I managed to get something usable in case they requested a print. I got back to my hiding spot in the other room, making small talk with other staffers and Secret Service agents working the night with me. Later, when they brought out the dessert with a lit candle on top, I rushed in to get a picture as they sang "Happy Birthday" to the First Lady as she made her wish. It's one of my favorite photos of her because she looks so genuinely happy to be surrounded by friends and family.

I think the toll of being away from his family when he was an Illinois State Senator, a U.S. Senator, and then running for president made him particularly sensitive to keeping his staff away from their families. He often said that the best part of being president was being able to get home (the shortest commute in Washington) by 6:30 or 7:00 p.m. for dinner with his family.

One of my favorite stories of the girls is from the first Turkey Pardoning in November 2009. It was one of the first events he did with just the girls. Sasha was eight, and Malia was eleven, and he delivered his best dad jokes and turkey puns to the media during his remarks. At the end of the event they placed Courage, the pardoned turkey,

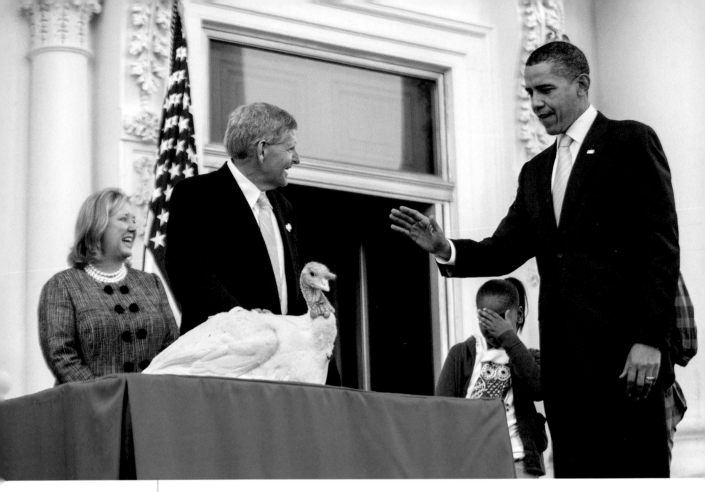

President Obama with daughters Malia and Sasha at their first Turkey Pardoning at the North Portico of the White House, November 25, 2009. The very first Turkey Pardon for the Obamas was one of my favorites. Bad dad jokes and all.

on the table, and President Obama waved his hand as if granting absolution. In the background is Sasha covering her eyes like she can't bear to witness what's about to happen—or maybe she can't bear another dad joke. In reality, she's just wiping her face, but the captured moment brings a smile nonetheless.

I can't say enough about the Obamas and their sense of family and its importance. Trying to create a semblance of normalcy for two kids growing up in the public eye is no easy task. They celebrated birthdays, holidays, and family time like the rest of us—just with a few more world leaders and A-list celebrities on the invite list.

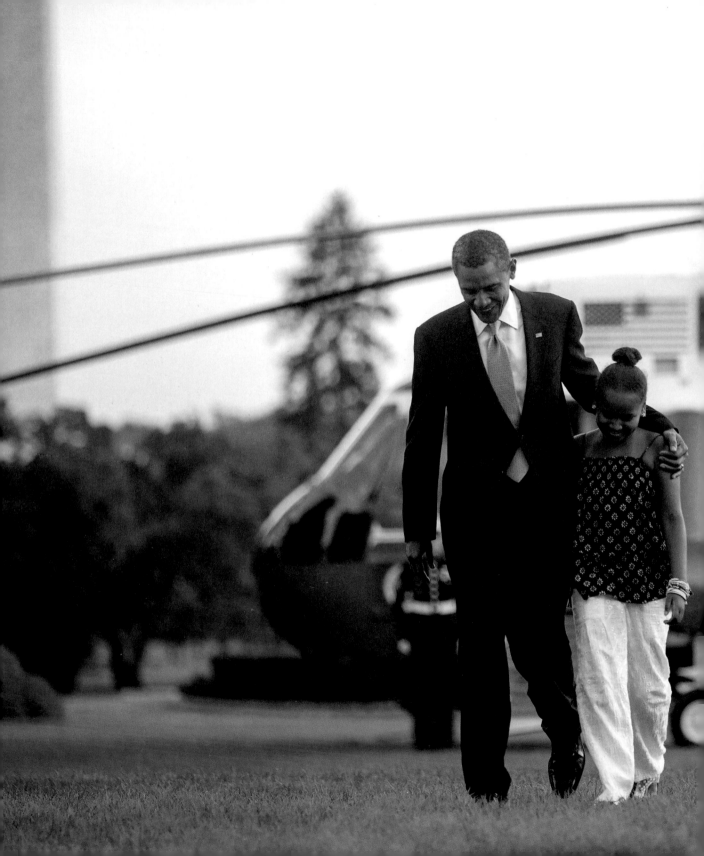

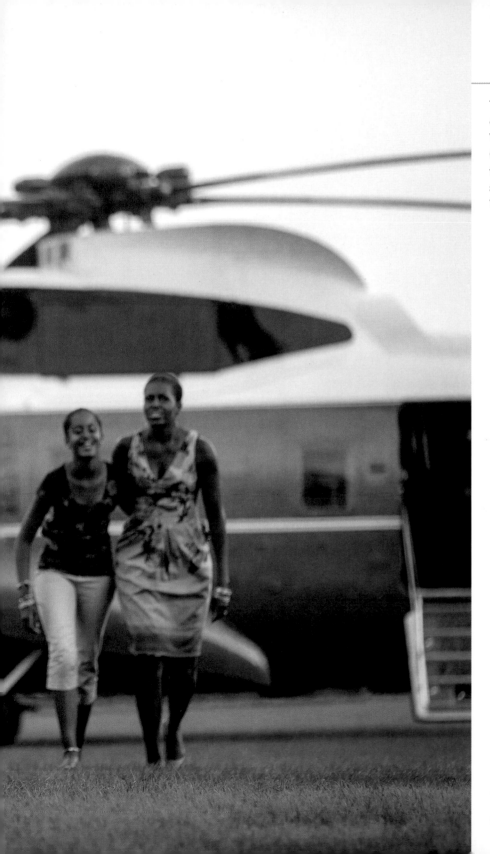

The First Family arrives on the South Lawn of the White House from Marine One, August 29, 2010. The family was coming back after a vacation on Martha's Vineyard.

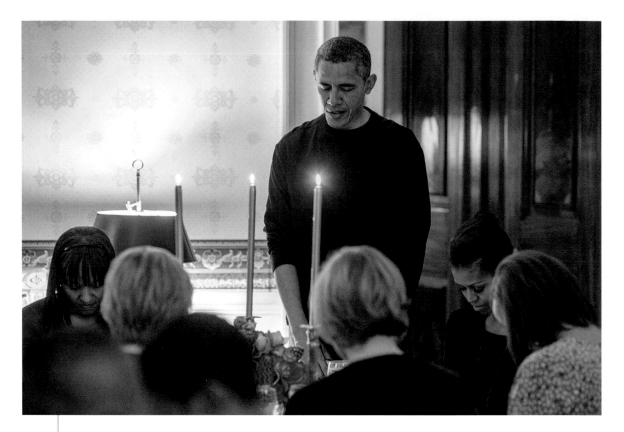

President Obama says grace before the Thanksgiving meal with friends and family in the Blue Room of the White House, November 24, 2011.

RIGHT: Friends and family of the President and First Lady gather on November 24, 2011, in the Blue Room of the White House to celebrate Thanksgiving.

President Obama and his former Chief of Staff Rahm Emanuel talk with Malia
as she arrives home from school, on the driveway of the South Lawn of the
White House, October 7, 2015. The two men were catching up while taking a
walk around the loop of the South Lawn driveway.

Michelle Obama makes a wish before blowing out the candle at her surprise birthday dinner thrown by President Obama at Restaurant Nora in Washington, D.C., January 16, 2010.

First Dog Bo running along the South Lawn of the White House with the First Family, shortly after joining the family, April 14, 2009.

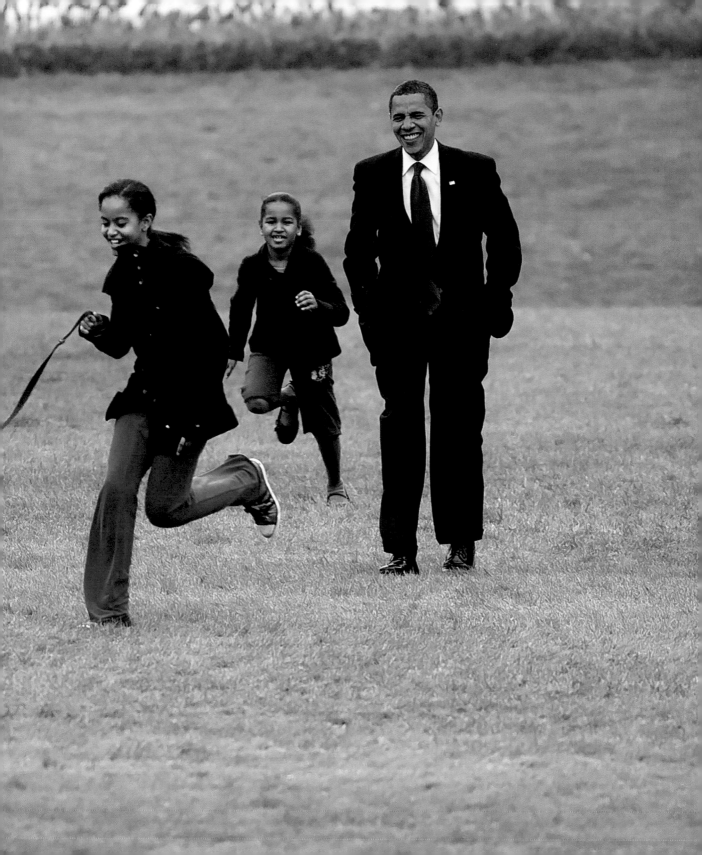

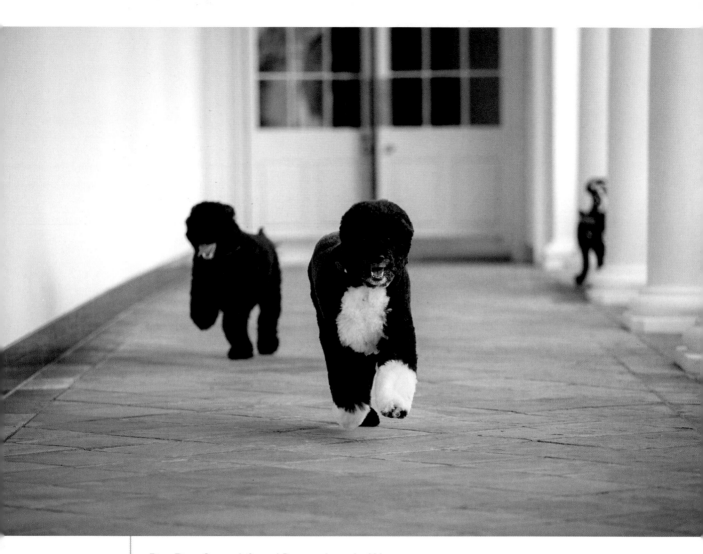

First Dogs Sonny, left, and Bo run along the West Colonnade of the White House, January 4, 2017. Their boundless energy never failed to lift spirits in the White House.

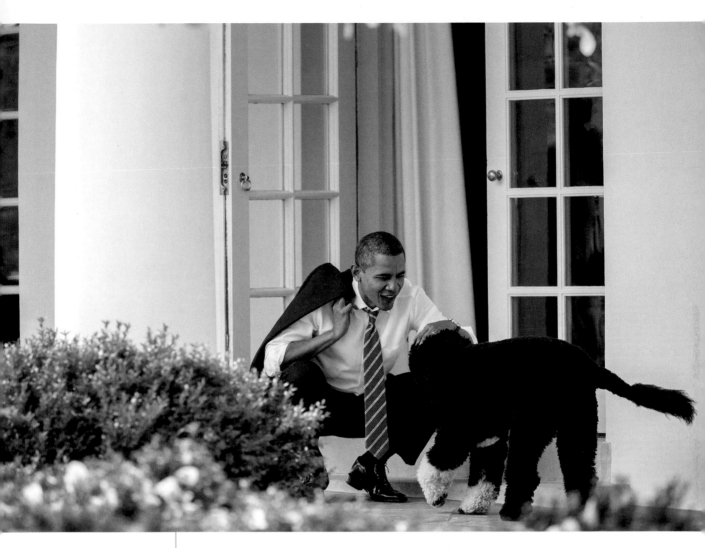

President Obama pets First Dog Bo outside the
Oval Office along the West Colonnade of the White
House, March 3, 2015.

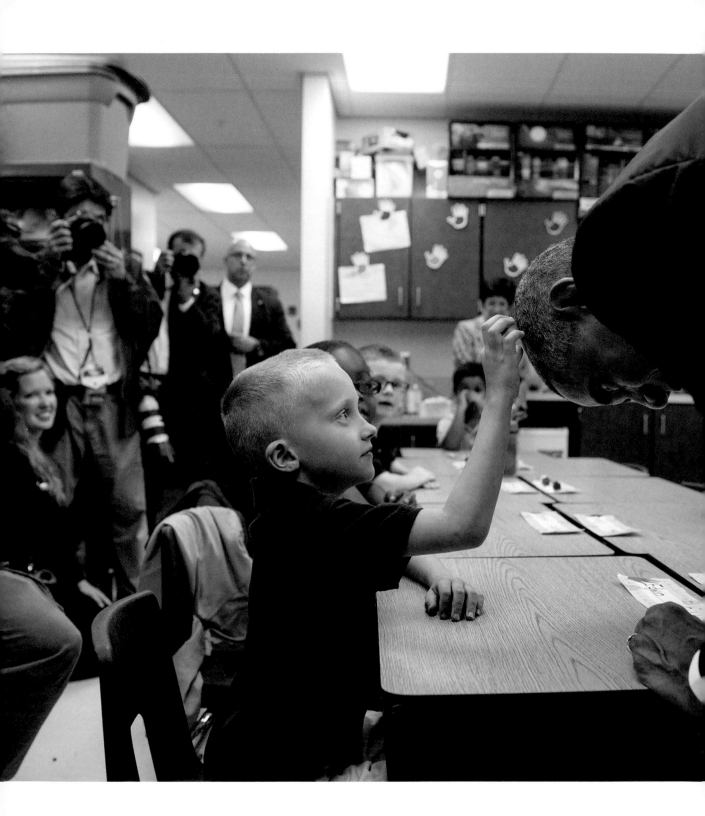

KEEPING IT REAL

How many sitting presidents sing a few lines of Al Green's "Let's Stay Together" impromptu in front of an audience? Which presidential candidate lists HBO's *True Blood*—a bloody and graphic show about vampires—as one of his favorite shows? Which First Lady competes in a push-up contest on *The Ellen Show* or raps in a song to help promote enrollment in higher education for low-income students? Time and again Barack and Michelle Obama rewrote the script of First Couple of the United States by doing something unexpected—and, more to the point, true to themselves. Young people identified with them because they're fans of hip-hop, R&B, rock and roll, jazz, and so many other forms of music. And they love sports. Defy-

President Obama allows first grader Edwin Caleb to touch his hair during a classroom visit at Tinker Elementary School at MacDill Air Force Base in Tampa, Florida, September 17, 2014.

ing the wishes of his staff, President Obama wore his Chicago White Sox hat during a first pitch at the Washington Nationals season opener. There were boos throughout the stadium, but he didn't mind one bit. He's a White Sox fan for life.

It's the biggest lesson I've learned from watching them up close: be authentic. Take away the prestige, titles, positions, and money, and you have your words and actions to define you—an unvarnished truth of who we are as told by what we do and say. Humans relating to other humans without pretense and reminding us that we have more in common than the differences on the surface might suggest.

I overheard hundreds of conversations they had with people from all walks of life—world leaders, wounded soldiers, factory workers, college students, the elderly, scientists, average people on the street, and many more. Their conversations were unscripted and sometimes raw. Without exception, people felt as though they were truly being seen and heard.

This type of authenticity can't be faked. It can be imitated, but eventually people see the real you. I observed some interactions with them where people were skeptical at first. I could see it in the body language of a Wounded Warrior, being greeted by President Obama, who had perhaps only seen the Fox News version of him. Over the course of the conversation, he softened as he began to process the disparity between the image in his mind and the person in front of him. The same goes for politicians. When First Lady Michelle, "the Hugger in Chief," would genuinely hug and greet people with one of her sincere smiles, the skeptics were a bit uncomfortable and speechless at the same time. Watching these interactions up close was a master class in being yourself—giving others the respect of showing them who you truly are.

President Obama works the rope line, greeting members of the audience after delivering remarks on American manufacturing at a computer chip plant in Chandler, Arizona, January 25, 2012. This visit was the day after his State of the Union speech. As is customary, the President went on the road to tout elements of the speech directly to the American people.

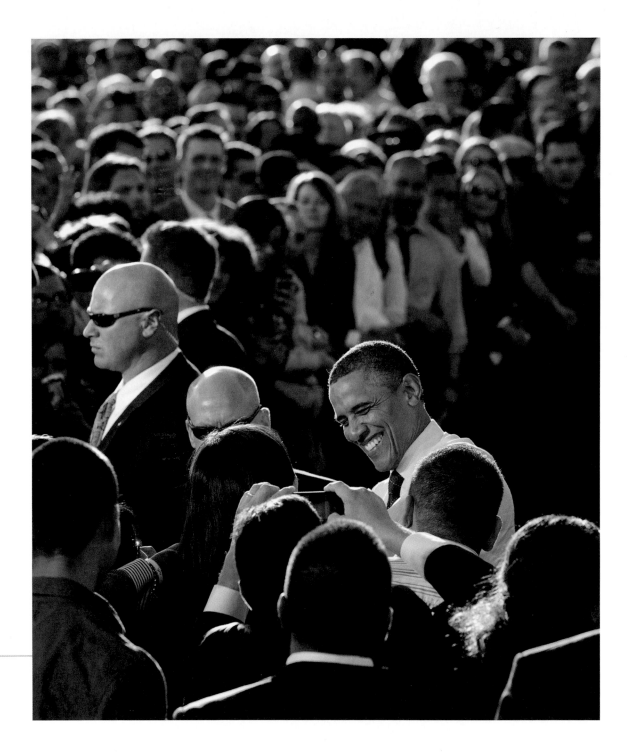

President Obama picks up a fly that he killed during an interview with CNBC in the East Room of the White House, June 16, 2009. Also pictured are CNBC reporter John Harwood, left, and White House Press Secretary Robert Gibbs, right. After killing the fly, the President declared, "That was pretty impressive, wasn't it? I got the sucker."

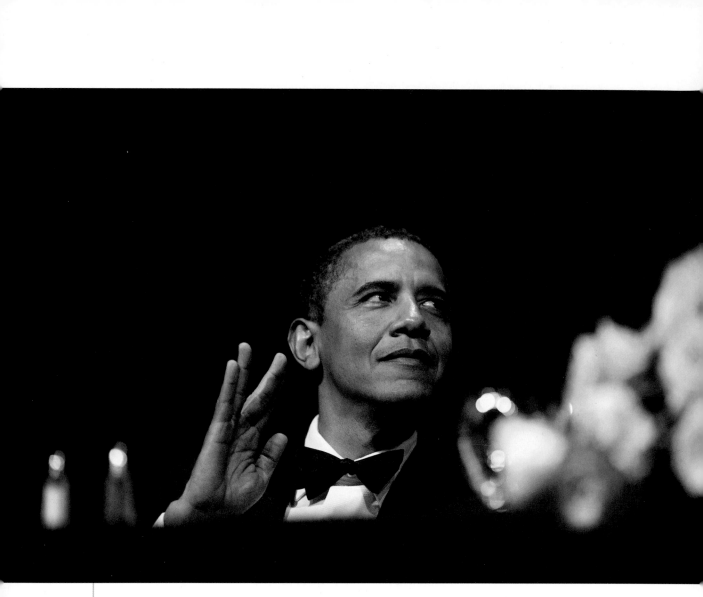

President Obama flashes the *Star Trek* Vulcan salute of "live long and prosper" at the Radio & Television Correspondents' Association Dinner in Washington, June 19, 2009.

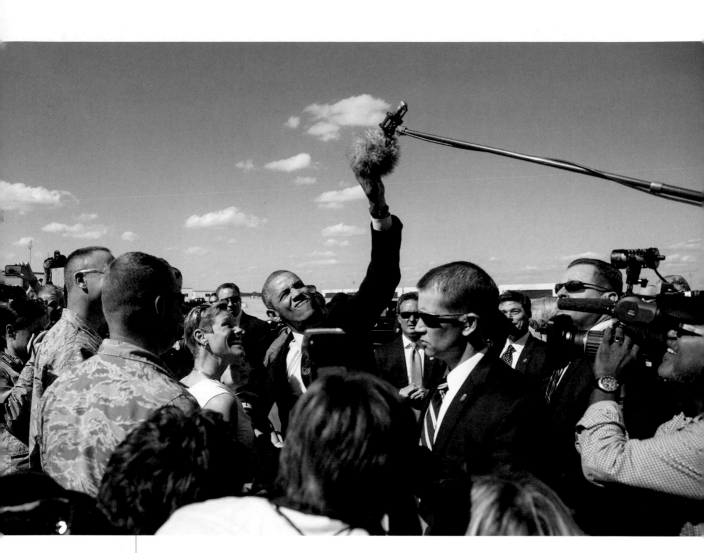

President Obama grabs at a microphone because a young toddler was fascinated by it, while greeting the crowd on the tarmac at Whiteman Air Force Base, Missouri, July 24, 2013.

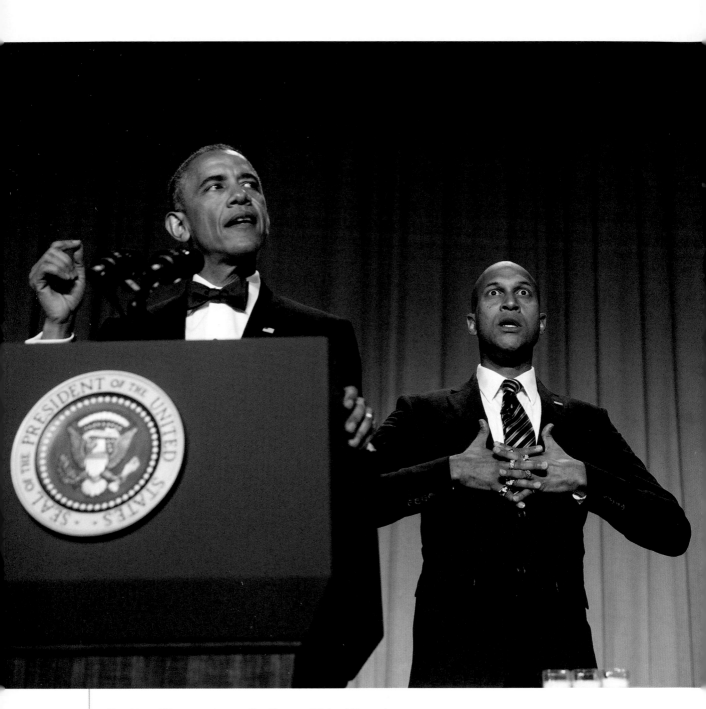

President Obama and comedian Keegan-Michael Key rehearse
and then perform remarks in the Map Room for the White House
Correspondents' Association Dinner, April 25, 2015.

GOOD TIMING

One of the funniest moments I photographed was the President rehearsing with actor and comedian Keegan-Michael Key, a.k.a. Luther, President Obama's "anger translator," in the Map Room in advance of the White House Correspondents' Association Dinner in 2015.

Key later recalled, "The President has an avuncular quality about him that I wasn't expecting. He gets right in there and hugs. He gave a couple notes when we were rehearsing, and I was like, 'You should be on our writing staff!' Then we got out there for real, and I almost got thrown at how great his timing was." ▪

President Obama greets players and guests after hosting the 2016 NCAA Champion University of Connecticut Huskies women's basketball team in the East Room of the White House, May 10, 2016.

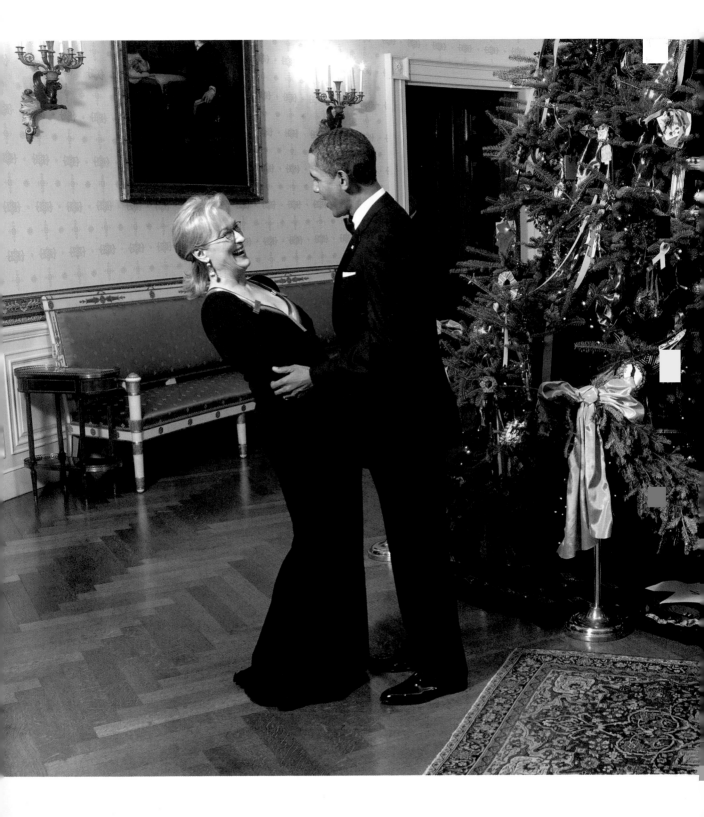

FAN-IN-CHIEF

"Meryl Streep! I'm a big fan!" President Obama exclaimed when greeting the award-winning actress as she entered the Blue Room of the White House for her picture with the President and First Lady. It was December 4, 2011, and she was receiving a Kennedy Center Honors Award for her career in acting. I don't know if this was the first time these two had ever met, but President Obama rattled off a half-dozen movies that she starred in and basically became a fanboy for that instant. The picture shows how caught off-guard she was by the adulation coming from the President of the United States, with the First Lady laughing at it all. So often the adulation and praise came from the guests, but every now and then it would flow the other way.

The First Couple greets Kennedy Center Honoree Meryl Streep in the Blue Room of the White House, December 4, 2011. The President had a starstruck moment that seemed to take Ms. Streep by surprise.

The President and First Lady greet Edith Childs in the Diplomatic Room of the White House during a White House reception, December 4, 2009. Ms. Childs is a community organizer who coined the campaign slogan "Fired Up! Ready to Go!" Her exuberant energy was matched by the President when she walked in the door.

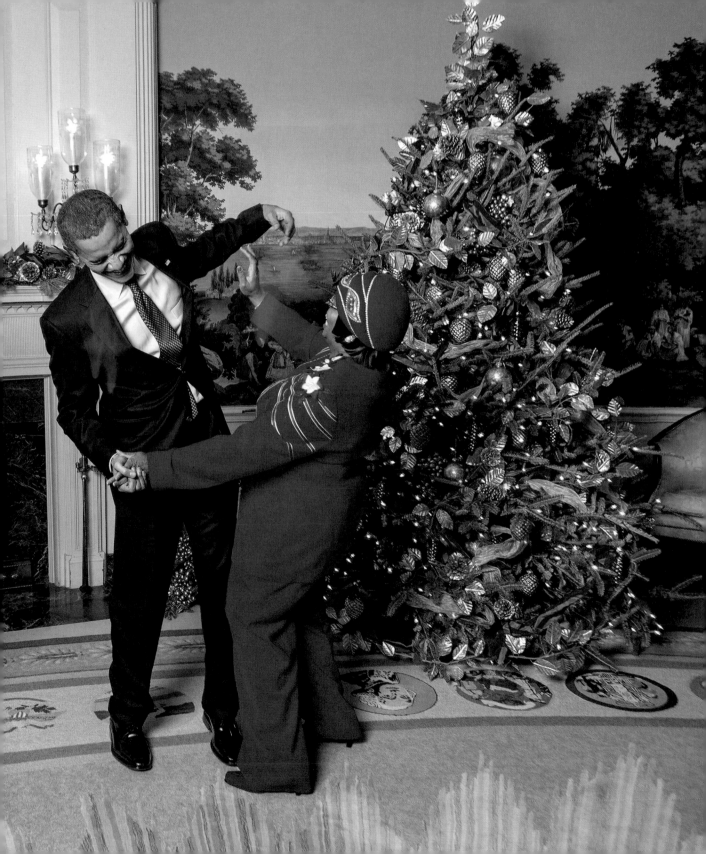

President Obama joins performers onstage at the conclusion of BET's "Love and Happiness: A Musical Experience" concert on the South Lawn of the White House, October 21, 2016. Performers include (from left to right): De La Soul: Vincent Mason, Kelvin Mercer, and David Jude Jolicouer; Bell Biv DeVoe: Mike Bivins, Ricky Bell, and Ronnie DeVoe; Regina Hall; and Terrence J.

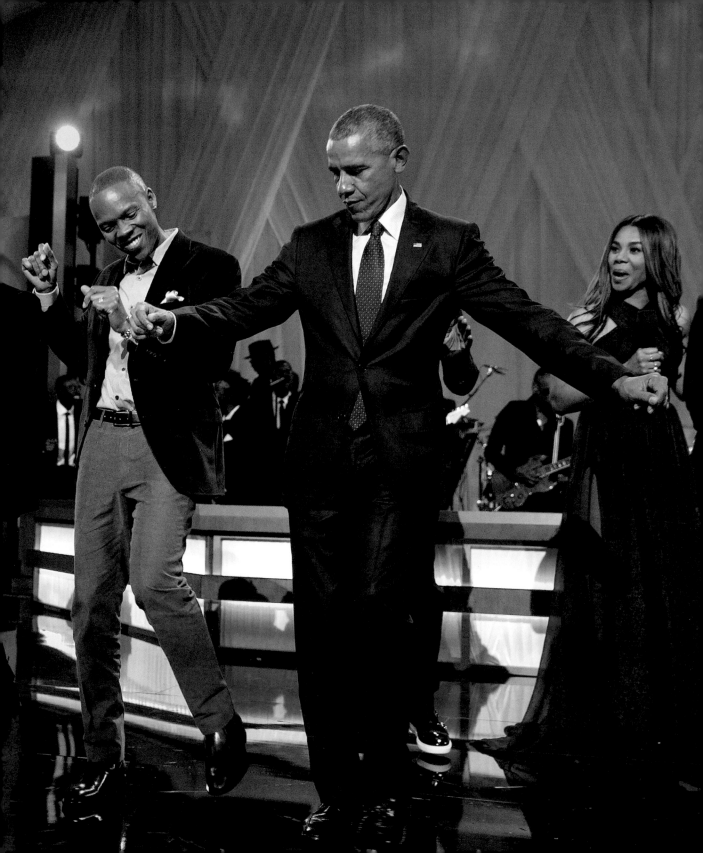

"For Cara and me, the word that comes to mind when describing our feelings about that day would be *surreal*—and very surprised. Our reception was at Renditions Golf Course, and upon leaving our wedding ceremony to make our way there, we were told there was "police activity" at the golf course. When the limo pulled up and we saw all the police cars and the black SUVs, we suspected some high-level VIP was there.

Once we got inside, we were told that the President was there playing golf and that we might be able to see him when he came off the course. Our special day was suddenly even more special.

Amazingly, the President came through the reception room, shaking hands and greeting our guests. We actually went outside to see him as he was getting ready to leave and we shook his hand. At that point, Cara spoke up and asked if we could get a picture with the President, and he said, "Sure." We both felt how genuine and down-to-earth he is. So there we were, just have gotten married, arm in arm with the most powerful man in the world.

We feel truly blessed by this unforgettable encounter. Even now we can't believe it: "The President came to our wedding."

—SANDER PHIPPS, newlywed husband

The President poses for a photo with newlyweds Sander and Cara Phipps after playing a round of golf at Renditions Golf Course, Davidsonville, Maryland, September 19, 2015.

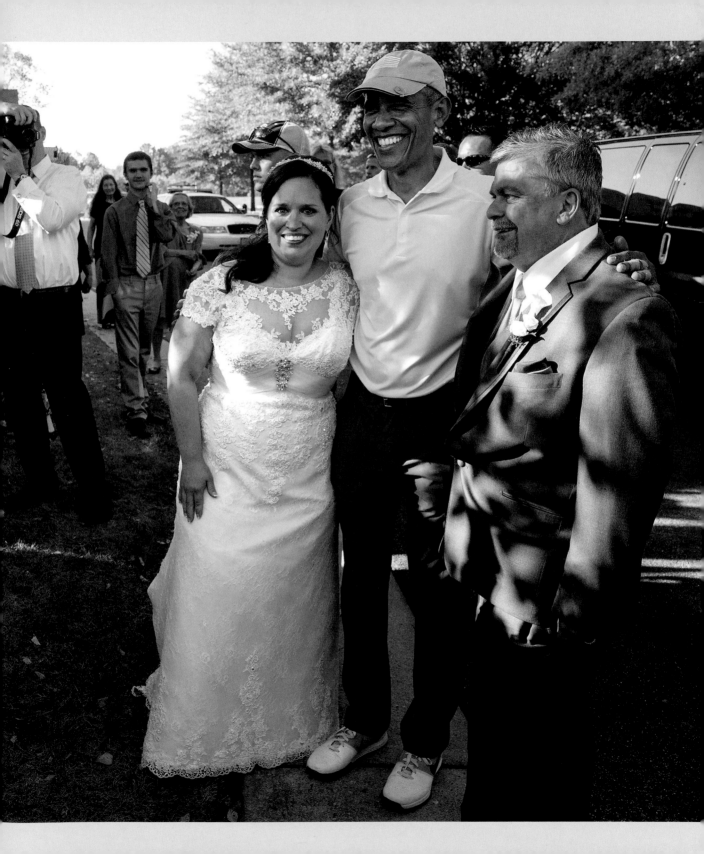

GOOD SPORT

"You tell your son I'm looking for a rematch," President Obama said to HUD Secretary Shaun Donovan in the lower Cross Hall of the White House after an event in the East Room. Turns out President Obama had lost to one of Donovan's sons, who was around thirteen at the time, in a Ping-Pong match during a Super Bowl party at the White House, and the loss was still on his mind.

I'VE ALWAYS BELIEVED THAT HOW YOU PLAY YOUR SPORT IS HOW YOU LIVE YOUR LIFE.

Most high achievers, I believe, are extremely competitive by nature. Having watched President Obama play golf and basketball over the years, I got to see how competitive he was around everything. He had a simple rule on the golf course and basketball court: "Don't treat me with any special favors because I'm President of the United States." His friends, before he became president, had no problem doing this, but the guests and friends who came after didn't quite have it in them to separate the two. President Obama can trash-talk with the best of them. But, at the end of every match or game, there were handshakes or hugs between the competitors. Sportsmanship at its best.

My first time covering him playing a round of golf was at Joint Base Andrews. It was a beautiful spring day, and I was amazed by the newness of it all. *I'm getting paid to be here*, I thought to myself. Even when the days weren't so lovely—extreme heat or cold weather—I never felt troubled or put out. As White House staffers, we knew how hard the President worked, and we knew that he deserved his time to do something that gave him joy, comfort, or distraction from the day-to-day pressures of being POTUS44. And somehow, over the course of eight years, he also went from shooting in the low 100s to a handicap of 12 to 14. I've always believed that how you play your sport is how you live your life. Some people call cheap fouls and can't leave the battle on the court when the game is over. Others elevate the game for all the players—and even lose a Ping-Pong match to a kid every once in a while. ∎

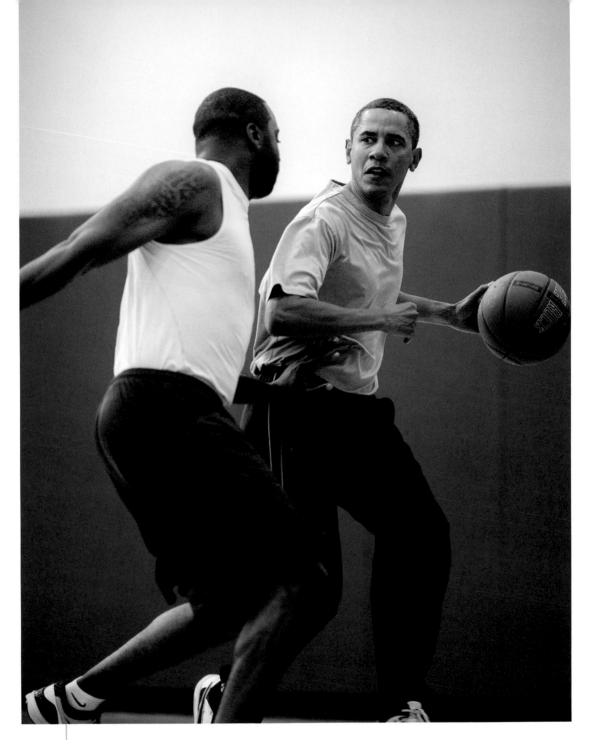

President Obama plays a pick-up game of basketball at Camp David, September 4, 2010.

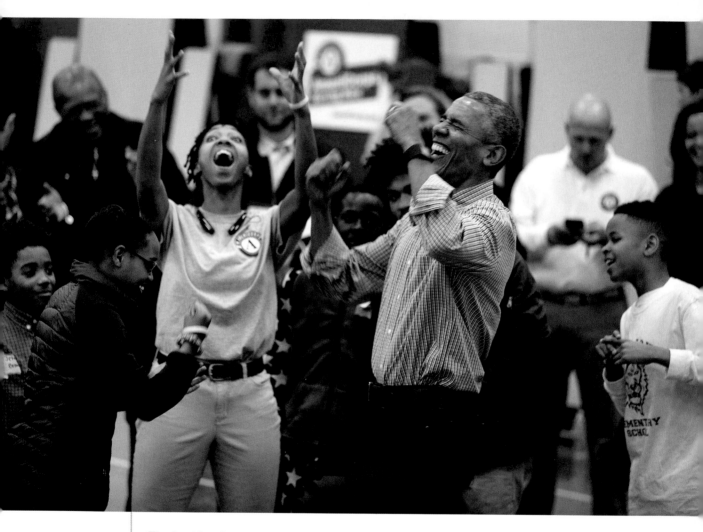

The President loses a game of Rock, Paper, Scissors as he participates in a community service project at Leckie Elementary School in Washington, D.C., January 18, 2016.

President Obama participates in a tennis clinic on the White House basketball court during the annual Easter Egg Roll on the South Lawn, April 6, 2015.

President Obama does push-ups after missing a shot during basketball drills at the White House Easter Egg Roll on the South Lawn, April 9, 2012.

RIGHT: President Obama plays a round of golf at the Joint Base Andrews golf course in Maryland, November 13, 2016.

Right after taking this photo, President Obama asked me, "Did you get that shot?" It always struck me that the confines of the Presidency are enormous. The President can't make a move off campus without involving thirty or more people. So having visits like this one with Kevin Durant helped brighten President Obama's day. It didn't have to be superstar athletes or celebrities. Make-a-Wish visits, staffers and their babies, and people of all walks of life were welcome guests, even for a brief visit. ▪

NBA All-Star Kevin Durant and President Obama talk and demonstrate a few basketball moves during an Oval Office drop-by, June 8, 2016.

President Obama waves good-bye to General Services Administration (GSA) staff after a group photo in the State Dining Room of the White House, January 17, 2017. This is the last photo I took during my eight years at the White House. The emotion in the room was palpable as the President shook hands and gave hugs to the staff who took care of the White House Complex while he was President.

President Obama watches a video montage from his early years in office as he participates in post–State of the Union interviews with moderator Steve Grove and YouTube creators sWooZie, Destin Sandlin, and Ingrid Nilsen, live from the East Room of the White House, January 15, 2016.

L ooking out from my window seat on Air Force One, at thirty-five thousand feet, all problems and issues of our time can seem small. But it's at ground level where you meet the people affected; the tough decisions, big and small, have consequences you can't ignore.

I'm neither naive nor a cynic. Mostly, I see the world as it is and not how I wish it were. But watching President Obama up close has shown me that hard decisions are made somewhat easier when you are doing what you truly believe to be the right thing.

Having the strength and conviction to stand behind your decisions when political pressures say otherwise is not easy. I was there when he gave the order to go after Osama bin Laden—when conventional wisdom was to just bomb the compound. During the 2014 Ebola scare in Africa, there were calls for a complete and total entry ban to all countries with documented cases of the disease from entering the United States. President Obama listened to the experts from the Centers for Disease Control and Prevention. Their choice of action wasn't politically popular, but I believe he saw through the noise and followed the best plan of action.

But the distractions he faced went beyond substance, policy, and politics. Typically, you run for office to debate and compromise about real issues—healthcare, immigration, the economy. But when a politician makes a derogatory comment about your wife's body, and another calls you a liar as you give a State of the Union address, or you are criticized for wearing "dad jeans" or a tan suit, it can make you wonder why anyone would sign up for this.

The scrutiny and judgment of the President, First Lady, and their family seemed to know no bounds, but they always stayed above the fray, maintaining their grace and dignity—and their sense of purpose. President Obama often remarked that making even small changes for the better is far greater than doing nothing. Through it all, he remained positive and inclusive and stayed on message in order to achieve his larger goals.

On the carpet in his Oval Office was the famous quote from Martin Luther King Jr.: "The arc of the moral universe is long but bends toward justice." Whenever I feel as though I'm not accomplishing or doing enough—as a father, son, co-worker, or human being—I remind myself of the big picture and trust that I'm headed in the right direction.

I've seen the Obamas a few times since the end of their administration. Each time it's gotten a little easier to make conversation and be less formal around them. Looking at them now, they seem more relaxed. The "weight" of the office and all its responsibilities isn't there anymore. I still say "sir" and "ma'am," but old habits are hard to break. In ten years, we've all changed. But their popularity hasn't. In some ways, it has only gotten stronger since leaving office. They are devoting themselves to causes, writing books, building a library, giving speeches, and delving into missions close to their hearts—particularly encouraging the next generation of young leaders. And they are vacationing and doing more of what they want to do. (Can you blame them?)

The example they've set has inspired countless people into action. Whether through politics, government, and corporate or charity work, there are Obamanauts out there making a difference in the world today, large or small. In whatever way I can, I'm inspired to be one of them. ▪

*O**bamanaut*** is my term for a person who not only saw something in Barack and Michelle Obama that inspired them to support, engage, volunteer, and work for the campaign or administration but more importantly saw them lead and inspire up close. Some of them started out as a high school or college intern or volunteer, while others came from academia or the tech world or were veterans of Washington, D.C., politics. Whatever path they took to joining the Obama administration, these staffers knew they were being called to join a new kind of effort, filled with hope and vision.

In 2017, a few months after the end of the Obama administration, I did an informal survey of former Obama White House staffers. I sent questions out to 300 of them and got back 167 responses. The blind survey asked general questions: How long did you work for the administration? Are you working in the field of your White House job? And so on. In response to the question "What was your greatest experience, lesson, or takeaway from working for the Obama administration?" the most common words used were *committed, team, matters, believe, family, relationships,* and *important.*

Whenever I can, I catch up with these former colleagues—asking them a few questions and doing an informal portrait—to see where their passion and dedication are taking them next. These are the newsmakers and leaders of tomorrow—and today, in some cases. They will be high-ranking civil servants, sitting on corporate boards, visionary elected officials, and maybe even president of the United States one day. But they will all have one thing in common. They were inspired by the first African American president and First Lady of the United States. ▪

ACKNOWLEDGMENTS

I would like to start with my family but especially my wife, Alicia. She sacrificed the most when I took the job as a White House Photographer. The long hours, days of travel, and things unexpected—she really came through for our family. And at the end of my time at the White House, it was through her encouragement that I decided to put together this book. I always thought I'd do something toward the end of my career—a retrospective of sorts. But she made the point that I should share my story now because it was unique and worth telling. So with the help of a family friend, Matt Gerson, who held my hand in the beginning of this process, I started on the journey of making it happen. To my in-laws, Patrick and Marcelle Leahy, who from the beginning welcomed me into the family, and who helped take care of Patrick and Sophia when I was on the road.

I can't go any further without thanking my mom, Arlene Jackson. She bought me my first camera and showed me what working hard for the family looked like. She did her best for me and my siblings, Lance, Jay, and Veronica. Scrimping and saving. Prodding and pushing. Praising and raising. She's always been supportive and protective of me.

My partner in crime has always been my twin brother, Lance. We lived in separate cities for about ten years after attending the same college (James Madison University), but we never let a month go by without seeing each other at least once. That meant a lot of drives between Norfolk and D.C. And flights between Boston and D.C. It's been the greatest thrill to now live less than a mile from him and his family and watch our kids—the cousins—grow up together.

To my professional mentors and peers along the way. Tommy Thompson taught me my first photojournalism class at JMU, and the world opened up quite a bit more for me. To Bob Lynn for hiring me as a staffer from an intern at *The Virginian-Pilot*—still one of the best photography newspapers in the country. But more importantly to Denis Finley, who took me under his wing and mentored me not only in photography but in life. Along with Bill Tiernan, Beth Bergman, Vicki Cronis-Nohe, and so many other staffers at *The Pilot*. They became my second family before I knew I needed one. To my Associated Press brothers and sister. "Once AP, always AP" is the phrase that comes to mind. I had traveled before, but

working for the AP gave me a shuttle pass to see parts of the United States and the rest of the world that I would otherwise never have gotten to see. And all the while making pictures and telling stories along the way.

Big thanks to my book editor, Marian Lizzi, her assistant, Rachel Ayotte, and my agents, Bridgette Matzie and Becky Sweren—they too held my hand and showed extreme patience with me throughout this process. Thank you!

Inspirational is the best word to describe my time at the White House. Working with a multitude of talented and dedicated public servants, both civilian and in the military. People heard the call to serve and could not ignore it. I'd like to thank Pete Souza for hiring and giving me the chance to work with Chuck Kennedy, Alice Gabriner, Samantha Appleton, Amanda Lucidon, David Lienemann, Shelby Leeman, Tim Harville, Janet Philips, Rick McKay, Al Anderson, Kim Hubbard, Jared Ragland, Katie Bradley Waldo, Jordan Brooks, Nora Verlaine, Anna Ruch, Chris Mackler, Arun Chaudhary, Jenn Poggi, Jim Preston, Amy Rossetti, Phaedra Singelis, Sonya Hebert, Keegan Barger and all of the White House Photo interns who helped make our office run. I'd be writing all day if I had to name every person I worked with at the White House, but I can't go by without naming Bobby Schmuck, Joe Paulsen, Melissa Winter, Hope Hall, Marvin Nicholson, Terry Szuplat, Chynna Clayton, Kristen Jarvis and all the permanent White House Residence Staff (they are the real institution).

I'd also like to thank those who contributed to this book. People who took the time to share their thoughts and insights on images and moments helped make this book more than a collection of pictures with captions. The best experiences are shared, which is what we tried to accomplish in this book.

Last, but most important, I want to express my sincerest and deepest gratitude to President Obama, First Lady Michelle, Sasha, Malia, Mrs. Robinson, Vice President Biden, Dr. Jill Biden, and their entire families for allowing me to bear witness with a camera in hand to such an historic time in our lives. I know history will favor them for what they've accomplished, but their greater mark will be on those they've inspired and what good works they will achieve.

ABOUT THE AUTHOR

Lawrence Jackson has been taking pictures since he was fifteen years old. From high school, to college, to newspapers, to wire services, and finally to the White House under the Obama administration. Lawrence has had the experience of a lifetime with a camera in hand.

ADDITIONAL CAPTIONS

page ii: President Obama delivers remarks on education and college affordability to the students of Georgia Institute of Technology (Georgia Tech) in Atlanta, Georgia, March 10, 2015.

page vi: President Obama, with White House Communications Agency staffers all around, puts on his tie before a White House videotaping in the State Dining Room, August 9, 2013.

page ix: A tight shot of President Obama's hands during a Q&A with the White House press pool in the Oval Office of the White House, March 17, 2014.

page 7: President Obama tapes his weekly address in the Diplomatic Room of the White House, May 29, 2009. He was the first (and only, so far) president to use the video format to communicate to the American people each week.

PAGES 6-7

A silhouette of President Obama during a rally with New Jersey governor Jon Corzine in Holmdel, New Jersey, July 15, 2009.

The audience listens to President Obama as he delivers remarks on the Affordable Care Act at George Mason University, in Fairfax, Virginia, March 19, 2010.

Reporters and White House staff in the Oval Office during a press availability with President Obama and Brazilian president Dilma Rousseff, April 9, 2012.

First Lady Michelle Obama visits and tours Burgess-Peterson Elementary School in Atlanta, Georgia, February 9, 2011.

President Obama listens as a question is asked after delivering a statement to the press in the South Court Auditorium of the Eisenhower Executive Office Building, March 11, 2011.

The First Couple walk to board Marine One on the South Lawn of the White House, April 4, 2010.

Navy hats lay on a sofa before President Obama greets the Navy Cyber Defense Exercise Team in the Diplomatic Room of the White House, May 7, 2015.

President Obama delivers remarks at the 2015 Presidential Ambassadors for Global Entrepreneurship (PAGE) and Young Entrepreneurs event in the South Court Auditorium of the Eisenhower Executive Office Building, May 11, 2015.

President Obama departs the South Lawn of the White House aboard Marine One en route to Austin, Texas, March 11, 2016.

The First Lady practices backstage prior to delivering a speech at the Democratic National Convention at Time Warner Cable Arena in Charlotte, North Carolina, September 4, 2012.

PAGES 84–85

White House staffers prepare the Roosevelt Room in the West Wing of the White House for a meeting that will be attended by President Obama, October 3, 2011.

Kristen Jarvis, former Deputy Senior Advisor and Director External Relations for the First Lady, goes over the First Lady's schedule on a trip to New York to do the talk show circuit, February 9, 2011.

White House Press Wrangler Ben Finkenbinder, left, and Deputy Associate Director for White House Communication Josh Lipsky work on directing the press during the U.S.–India state arrival ceremony, November 24, 2010.

White House Trip Director Marvin Nicholson on a Night Hawk helicopter headed to an airport in Michigan, June 6, 2010. President Obama had just given a surprise commencement address to a local high school.

White House stenographer Eirene Busa listens and smiles as First Lady Michelle Obama gives an interview in the Map Room of the White House, February 10, 2011.

Nate Tibbits, Executive Secretary for the National Security Council during the Obama administration, participates in two phone calls on board Air Force One, February 18, 2011.

Special Assistant to the President, Reggie Love (left), and White House Doctor Jiffy Seto in the backseat of the "spare" presidential limousine known as "The Beast" on their way to an event with President Obama in Washington, D.C., August 3, 2011.

Waiting for President Obama, a U.S. Secret Service agent holds the door to the presidential limousine known as "The Beast" in Hanover, Germany, April 24, 2016.

Associate Director of Scheduling and Advance and Trip Coordinator for the White House, Jordan Whichard holds President Obama's notes to keep them from blowing away as Marine One taxis to a stop at Joint Base Andrews, July 2, 2010.

A White House server looks out the window of the Red Room of the White House, November 27, 2015.

National Security Council staffer Valerie Boyd waits as a phone call from a world leader is being connected in the Oval Office, October 24, 2009.

Military Aide to the President, Lieutenant Colonel Reginald McClam, stands by with other service personnel for a departure on Marine One from the South Lawn of the White House, May 18, 2012.

PAGE 90

President Obama and White House Senior Advisor Valerie Jarrett watch the news reports of Dylann Roof's capture in the Outer Oval Office of the White House, June 18, 2015.

President Obama and Vice President Biden wait with staff in the Lower Press Office of the West Wing of the White House before making a statement on the mass shooting in South Carolina, June 18, 2015. From left to right: Jenn Friedman, POTUS44, Desiree Barnes, Joe Paulsen, Brian Gabriel and VPOTUS Biden.

President Obama departs the dais after delivering a statement on the shooting in South Carolina with Vice President Biden from the Brady Press Briefing Room of the White House, June 18, 2015.

President Obama delivers a statement on the shooting in South Carolina with Vice President Biden from the Brady Press Briefing Room of the White House, June 18, 2015.

President Obama, with Director of Speechwriting Cody Keenan, drafts a statement on the mass shooting in Charleston, South Carolina, in the Outer Oval Office of the White House, June 18, 2015.

PAGES 100-101

First Lady Michelle Obama arrives and disembarks Bright Star upon arrival at LaGuardia Airport in New York, New York, February 2, 2016.

The feet of the First Lady in the green room before going onstage to participate in an Honoring Young Women from Military Families event in Jacksonville, Florida, April 12, 2012.

The First Lady delivers remarks at Georgetown University, in Washington, D.C., November 8, 2011.

The First Lady signs covers of *MORE* magazine after delivering remarks during the MORE Impact Awards luncheon at the Newseum in Washington, D.C., June 29, 2015.

The First Lady with her eyes closed during the invocation and before her commencement address at Spelman College in Atlanta, Georgia, May 15, 2011.

First Lady Michelle Obama introduces President Obama at Langley Air Force Base in Virginia, October 19, 2001, where he announced a new private sector initiative on hiring twenty-five thousand veterans into the workforce.

First Lady Michelle Obama greets students following a flash mob dance at Alice Deal Middle School in Washington, D.C., May 3, 2011.

The First Lady greets students from the Young Women's Leadership School of Astoria backstage before the Media with Purpose and American Magazine Media Conference in New York, February 2, 2016.

White House Chef Sam Kass tends to the White House Kitchen Garden on the South Lawn of the White House, February 2, 2011.

PAGES 172-173

Eric Waldo, former Director of Reach Higher in the First Lady's Office and now Executive Director of Michelle Obama's Reach Higher Initiative and Chief Access and Equity Officer at the Common Application pictured in his office December 4, 2017.

Maurice Owens, a former Special Assistant to the White House Chief of Staff, who now works for the Libra Group in Washington, D.C. This picture was taken at the Lincoln Memorial, January 27, 2018.

Former White House Creative Director under the Obama administration, Ashleigh Axios, at her home in Washington, D.C., February 5, 2018.

Rumana Ahmed, 29, a Harvard Kennedy School of Government student, pictured on the campus of Harvard University, Cambridge, Massachusetts, September 6, 2018.

Paul Monteiro, former White House Public Engagement Advisor under the Obama administration, who ran for County Manager in Prince George's County in 2018. He is seen here campaigning in PG County, June 6, 2018.

Portrait of Michael Smith, a former Special Assistant to the President and Senior Director of Cabinet Affairs for My Brother's Keeper and the current director of My Brother's Keeper Alliance, in their Washington, D.C., office, October 12, 2018.

Former Policy Director for the First Lady, Krishanti Vignarajah, spent five years working for the Obama administration, and is pictured at her fund-raiser in Annapolis, Maryland, December 10, 2017. She spearheaded Let Girls Learn, an international coalition designed to help girls complete middle and high school.

Beck Dorey-Stein, former White House stenographer, in her parents' home in Narberth, Pennsylvania, January 3, 2018. Beck is the author of *From the Corner of the Oval*, a memoir about her life during the White House years.